# WILLIAM ALBERT ALLARD

# THE PHOTOGRAPHIC ESSAY

BY ERLA ZWINGLE AND RUSSELL HART

INTRODUCTION BY SEAN CALLAHAN

AMERICAN PHOTOGRAPHER MASTER SERIES   HENRY HORENSTEIN, EDITOR

A BULFINCH PRESS BOOK   LITTLE, BROWN AND COMPANY

BOSTON   TORONTO   LONDON

A Pond Press Book

First edition

Edited and produced by Henry Horenstein, Pond Press
Designed by DeFrancis Studio, Boston
Production coordinated by Christina M. Holz
Printed and bound by Dai Nippon Printing Company, Ltd.

*Library of Congress Cataloging-in-Publication Data*
Allard, William Albert.
   The photographic essay.
   (American photographer master series)
   1. Photography—Portraits.   2. Allard, William Albert.
I. Zwingle, Erla.   II. Hart, Russell.
III. New York Graphic Society.   IV. Title.   V. Series.
TR680.A46 1989      770'.92'4      88-8886
ISBN 0-8212-1674-0 (hc)   ISBN 0-8212-1735-6 (pb)

Bulfinch Press is a trademark of Little, Brown and Company (Inc.)
Published simultaneously in Canada by Little, Brown & Company (Canada) Limited

Printed in Japan

# CONTENTS

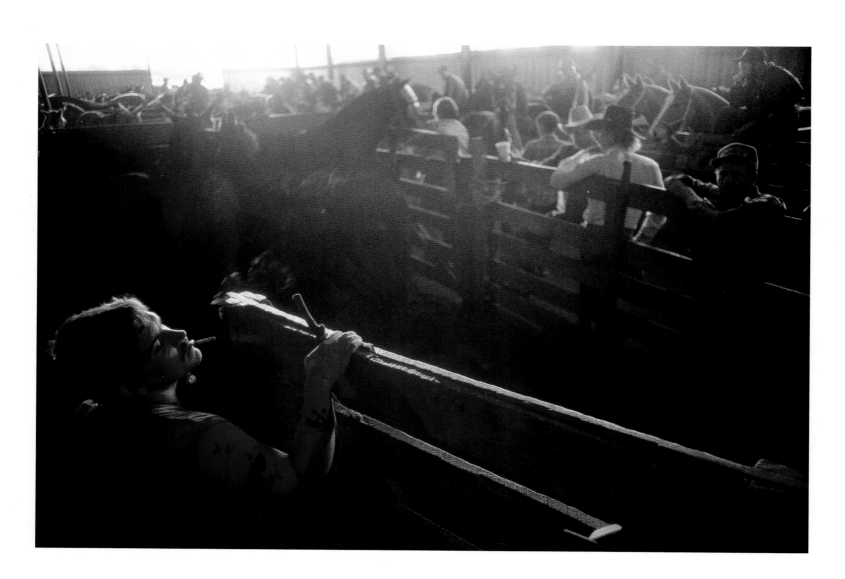

MISSISSIPPI 1987

TO THE MEMORY OF MY MOTHER AND FATHER, GEORGE AND WILLI ALLARD

# INTRODUCTION

The *American Photographer Master Series*—like the magazine—intends to provide the advanced and professional photographer with insight into the lives and working methods of today's leaders in photography. In ten years of publishing, the magazine has profiled some of the most celebrated talents and previewed the work of many others. Often, the magazine format has a limited ability to tell the complete story. This series, produced in association with Pond Press and New York Graphic Society Books, is an attempt to correct that.

William Albert Allard is an especially apt choice to lead off the series. An *American Photographer* July 1984 profile describes him as a prodigy and maverick. If the talented photographers in this series share anything, it is a unique independence—of vision as well as character.

A native Minnesotan, rooted to the simple, straightforward, values and wry self-deprecation that Garrison Keillor celebrates in his *Lake Wobegon* stories, Bill Allard is more likely to tell you about the pictures he's missed than the ones he's made. He's not afraid to expose his foibles and frailties.

The better you know Allard, the more contradictions you find. For all his Midwestern self-effacement, this son of a Swedish flatbread maker has boldly carved his name in contemporary photography. His palette ranges from the subtly hued expanses of the Old West to the vibrant colors of native Latin America. He lives in rural Virginia, but his character has more in common with the image of the Marlboro man, whose visage Allard has documented in great detail. His principal outlet for the past 25 years has been in the pages of *National Geographic*, yet after early success there, he left a lucrative staff position for the uncertain demands of freelancing.

Although he brings additional cameras and lenses as backups, Allard's equipment, when working, is minimal: a couple of camera bodies and two or three lenses. He

stubbornly adheres to Kodachrome—a notoriously unforgiving film—and then pushes it to the limits of acceptability with precariously long hand-held exposures further complicated by mixed lighting sources.

What makes Allard run in all these diverse directions and respond to seemingly contradictory impulses is the real subject of this book. His career is proof that only in taking risks—and being unafraid to fail in the process—can original work be created. And, while the life, work, and methods of Bill Allard might not make the ideal role model for anyone else, knowing him can be a valuable experience for any photographer.

We invite you to get to know William Albert Allard.

Sean Callahan
*American Photographer*, Editor (1978–1988)

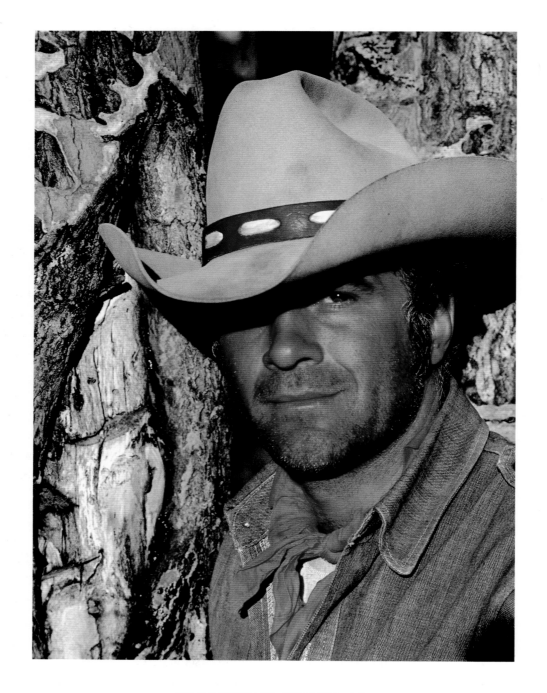

SELF PORTRAIT, WYOMING 1971

# WILLIAM ALBERT ALLARD

In twenty-five years with a camera, primarily for *National Geographic* magazine, William Albert Allard has vividly expressed firm convictions, intense emotions and indisputable talent. A consummate photographer of people, he has made images in which emotional insight combines with striking design to create a powerful, unforgettable whole. He has also baffled his friends, frustrated his enemies, periodically shot himself in the proverbial foot, and bemused countless innocent by-standers. His kudos read like blurbs from movie reviews, befitting a man with an acknowledged flair for the dramatic: "An exceptional talent." "In a strange way, a genius." "Totally dedicated." "A bit of a fanatic." The man does not inspire indifference.

"Bill cares enormously what people think about his work," says one of Allard's colleagues. "But he doesn't give a good goddamn what people think of *him*." And yet Allard's work *is* him. "You get a very powerful sense of the photographer's life, his taste, his values from it," says his fellow *National Geographic* photographer Sam Abell. "You'll find his world view in any tray of his work." Allard himself puts it even more succinctly. "With me," he says, "what you see is what you get."

What you see when you meet the photographer is a man of moderate height with broad shoulders and clear hazel eyes. A pipe of some form is clamped in his teeth. His shirtsleeves are rolled back. Not much of his silvering hair shows beneath his ever-present hat, which is usually some variation on the cowboy motif. Likewise hand-tooled cowboy boots, Levis with their back pockets worn to the outlines of an overstuffed wallet and a tobacco pouch, and a Swiss Army knife snapped into a leather belt holster. Possibly a denim jacket; definitely blue notes scribbled by ballpoint as reminders across the back of his left hand. Resonant baritone with a Minnesota cadence, a voice that intensifies as his opinions avalanche. And a magnetism that intrigues potential subjects,

from Amish girls to Peruvian shepherd boys; something that seems, by the evidence of countless photographic essays, to inspire trust. "People remember Bill," says Abell. "He's not tall, but he has a lot of presence."

For a high plains drifter, Allard's roots are really Lake Wobegon, a colleague once remarked. He was born September 30, 1937, and raised in Minneapolis to a father who was a first-generation Swedish immigrant. His mother was of German extraction. The couple was Lutheran, hard-working, blue-collar, Depression-era cautious. George Allard worked most of his life as foreman in a Swedish flatbread bakery, picking up extra money by playing accordion or violin, with his wife at the piano, for dances at the local Scandinavian lodges. All three of his sons took up the trumpet. Bill taught himself to play by ear, and he sang in a high-school *a cappella* quartet, sometimes for money. He was also regularly in some variation of boys-will-be-boys trouble, "a bit of a renegade, a risk-taker," recalls his sister Ann de Gray. On a bet, he climbed a thirteen-story ice-coated fire ladder in the dead of winter. He hitchhiked from Minnesota to California and back again, also in the dead of winter. He read voraciously about the Old West and idolized the mountain men: "They answered to *nobody*," he says, explaining their appeal.

Allard graduated from Patrick Henry High School in 1955 and went to work as a construction lineman for Northwestern Bell Telephone. "It was fun climbing the poles in nice weather," he said later, "but I didn't want to do it until I was 50." In 1957, barely 20, he married Mary Kay Burns, a high-school girlfriend. Two years later, he sent himself back to school, enrolling at the Minneapolis School of Fine Arts (now the College of Art and Design) to study design and graphic arts. "I had bad high-school grades, and it was the only place I could get into," he confesses. "I could always draw pretty well as a child, though." A year of "twisting wires and waiting for lunch" produced little worthwhile art, but two other things: the determination not to become "one of three hundred acres of commercial artists making greeting cards," and the desire, instilled by a smattering of English classes, to be a writer. In 1960 he transferred to the school of journalism at the University of Minnesota.

Allard's academic commitments had to compete with considerable domestic responsibilities. He was becoming a father with alarming regularity (four children in four years) and contrived to make money by driving a beer truck, managing a cocktail lounge, selling his blood, and working the freight docks for a trucking line. "I learned a lot about people in all those jobs," he says, "and my interest in photography is people. If you want to photograph people, you'd better know something about them."

*Minneapolis 1962*

"Serendipity" is one of Allard's favorite words, a principle he all too often credits, along with intuition, for the success of his photographs. But it certainly played a big part in his decision to attend a lecture one day in 1962, given by photojournalism professor R. Smith "Smitty" Schuneman. The subject: the photographic essay. The message: words and pictures can work together to communicate more powerfully than either alone. Allard realized immediately the importance of this idea. He signed up for a beginning course in photography, equipped himself with an old Argus C–3 camera, and totally immersed himself in his new passion. "I'd sit up late at night looking at pictures by Capa and Cartier-Bresson when I should have been studying Spanish," he recalls. "They just seemed to say to me, 'This is what you can do. This is a means of communication.' It was the first thing I'd ever found that I really wanted to do.

"I told my friend and classmate Ray Lustig (now a photographer for *The Washington Post*) that I wanted to be a magazine photographer, to work at a certain level, make pictures of a high caliber. I remember the look on his face: Yeah, sure. But I thought, Why not? Why wasn't it possible? And I remember thinking then, too, that although there was work I admired—Gene Smith, David Douglas Duncan—I didn't see any gods walking around in the magazine photojournalism profession. I felt I was capable of working at that level. Not right that afternoon. But eventually."

Because he was older than his peers, Allard felt driven by the need to make up time. His wife told him he was mumbling f-stops in his sleep. He was obsessed by *Let Us Now Praise Famous Men*, the classic documentary of 1930's Southern rural poverty in which Walker Evans' photographs and James Agee's words worked in tandem to create a powerful sense of the lives of sharecropper families.

Being older showed itself in the subjects Allard chose to photograph for Smith Schuneman's class. Being Allard showed itself in the way he approached them. "He was very solid," Schuneman remembers. "Even his first assignment was done on time. He was never satisfied with his level of expertise; as soon as he reached skills A and B, he'd be thinking about skills C and D.

"When Bill was in his second term I gave a 'Thematic Statement' assignment—a topic to probe in depth, not in terms of time or sequencing, but to find ways in which images related in terms of theme. To find ways to make a group of pictures function as one unit. That particularly excited and challenged Bill. By the end of the course it was pretty clear this young guy had a good eye, a good mind, and a very high level of goal-setting."

These self-imposed demands left little room for diplomatic maneuvering. "We had to do a project to show the progression of time just in one image," Ray Lustig recalls. "Allard did a picture showing Fords, from the Model T to the latest Thunderbird. They were all black except the last one, which was white. For some reason, Smitty took great offense at the white car, so Allard just went over to the paper cutter and whacked it off. Smitty's a very orderly guy—he was rather speechless."

Allard also took photography classes in the university's art department with Jerome Liebling, a student of Paul Strand and once a member of New York's Photo League, an organization of socially concerned photographers spawned by the Depression and dedicated to humanistic uses of photography. Though Liebling was a respected documentarian, he was of a very different school of photographic thought than was Smith Schuneman, one in which the formal aspect of the picture was as important as (and integral to) its content. "Smitty was locked into a kind of journalistic purism," says Allard. "Liebling was much more liberal. He was really more of an influence aesthetically than Schuneman was." Allard tried "to make pictures I could take both places," and the attempt to satisfy both teachers augured the success with which Allard would reconcile the art of photography with its human importance.

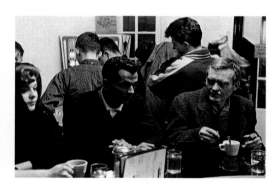

*Minneapolis 1963*

Allard's early pictures show all the distinguishing marks of his more mature work. His student projects included essays on a racially mixed married couple (rare in Minnesota in those days), a black evangelical church, and Lucy, a six-year-old girl with terminal cancer. These were sophisticated themes: emotionally intense, far from trivial, concerned with complex lives being lived outside the mainstream. Most of the pictures were shot in marginal lighting conditions and show an instinctive sensitivity to the power of the oblique glance and the tender nuances of shadow. They display an element of risk in confronting such subjects; there is compassion and an unabashed fascination with the power of the individual human face. The compositions are strong and simple, but more important is the intensity with which the photographer scrutinizes his subjects—and accepts their scrutiny in return. Says Rich Clarkson, former director of photography at *National Geographic* and one of Allard's champions, "All Bill Allard stories are about people."

At Schuneman's suggestion, Allard prepared a portfolio, clawed together the airfare, and spent the spring vacation of 1963, his junior year, making the rounds of photo editors in New York. He particularly remembers calling on the late Arthur Rothstein, a former Farm Securities Administration photographer, then director of photography at *Look* magazine.

"He looked at my pictures very quickly, as I realized later editors have to do because they get besieged by people like me. He said, 'This is very good. I had a photographer in here this morning from Houston; he's been shooting for twelve years, but this work is equal to his.' I said, 'Well, that means I'll have to work that much harder next year.' Rothstein said, 'What do you mean by that?' I didn't mean to sound cocky, it was just the way I felt: I said, 'Next year I'll have to be better than that.' And he said, 'Even if you get to be as good as Dennis Stock, there are only so many jobs in the profession.'

"I was tired. I'd been spotting prints on the plane, and ever since I'd gotten into his office I'd been digging my own grave. So I said, 'Mr. Rothstein, I think if next year I'm as good as Dennis Stock, someone will find me some work.' "

Allard immediately looked up Dennis Stock's number and called to ask if he would see his portfolio. Stock, a successful freelancer with many publications to his credit (including a book called *Jazz Street*, which Allard owned), was sitting amid packing crates, preparing to move with his family to Europe the next day. But he invited Allard over. "We spread out the pictures, he mixed some screwdrivers. He was encouraging, but even if he hadn't been, it would have been worth every penny I'd spent going to New York, because that's what I was there for, for that exchange."

Allard had a fall-back position prepared. "I didn't want to be a newspaper photographer, because newspapers weren't capable of high-quality reproduction, and the kind of photographs I wanted to make required that. If I couldn't crack magazines—I was totally naive and had no idea how difficult it was—I thought I'd be a reporter, a writer."

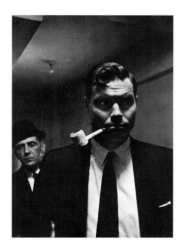

*George Lincoln Rockwell, Minneapolis 1963*

A year later he made the rounds again, this time in Washington, D.C. His most providential call was on the late Yoichi Okamoto, then at the U.S. Information Agency, and later Lyndon Johnson's official photographer. Okamoto looked at Allard's pictures and phoned Bob Gilka, the director of photography at *National Geographic* magazine.

Gilka already enjoyed a considerable reputation from years of work in newspapers. His unvarnished manner and fierce independence were destined to clash with the equally independent Allard. Their relationship over the next twenty years would be full of high respect and equally high words. "The stuff was very good," Gilka recalls, remembering Allard's essay on the terminally ill young girl. "But in a sense, in photojournalism that kind of subject is easy. If a photographer is quick and smart enough he'll get a good result, but it was obvious that this guy was better than that. It was a matter of his seeing. Allard had two things going for him: his seeing ability, and his determination, his dedication." Photographer Kent Kobersteen, a college classmate of Allard's and now assistant director of photography at *National Geographic*, agrees. "It

seems to me there are really good photographers, and ones with so-so eyes and lots of ambition," he says. " If I had to pick one for an assignment, I'd go with the ambitious guy. But Bill has a great eye, too."

Gilka offered Allard a summer internship and a warning. "If you can get anything else," he said, "you'd better take it, because the job doesn't pay any money and it's all over in the fall." Allard blurted, "Well, I've been busted for five years, another three months won't kill me and you might want to keep me," all in one breath. Two months later he started one of the most coveted jobs for beginning photographers, two days after his graduation from the University of Minnesota.

"I don't want to be known only as a *Geographic* photographer," Allard implores. But the fact remains that the majority of his most important work in the following two decades was produced for one of the few successful magazines with the economic resources and philosophical commitment to the in-depth photographic story. Unfamiliar with the magazine, Allard was far from sanguine about his prospects at the start of the summer of 1964. He had moved to Washington, the home base of the magazine since its inception in 1888, and was living alone in "the smallest hotel room known to mankind." And he was a complete stranger to color film, the stock-in-trade of *National Geographic* photography.

One day, Gilka suggested to his 26-year-old intern that he spend a few days making photographs at the Kutztown Pennsylvania Dutch Festival. "While you're there," said Gilka casually, "see if you can get a few pictures of the Amish. Don't worry if you can't." Gilka didn't mention that a staff photographer had returned earlier without anything usable. The Amish are a closed society; they do not espouse modern technology, including the camera, nor do they welcome the curiosity of outsiders.

Allard signed out a car from the *Geographic* fleet and followed his instincts. He stopped in Baltimore and bought a pair of used coveralls, and when he got to his motel in Pennsylvania he immediately went to the bar.

"I think the other photographer had gone to the local Amish bishop and asked him for permission to photograph his people," says Allard. "Well, the guy's bound to say no; what else could he say? So you don't go to the bishop. In small areas you can learn a great deal sitting around the local pub and just listening. One guy told me his father had a stone quarry and did business with the Amish. So through him I met an older Amish gentleman.

"I did what I always do, usually pretty early in an encounter: I told the man who I

Jack Hamilton

*Minnesota 1965*

was, who I represented, and what I wanted to do. In some cases, I'll even say why I think the work is important; with the Amish, I said it was to show a way of life that most people don't know about. You have to convince them that it's of value to do it, to do it right. Then it's up to them. Very often, I tell them, 'You don't know me. There's no reason why you should trust me.' I don't think I'm a great salesman; I'm not capable of going in and telling somebody, 'Hey, let me do this and it's gonna be the greatest story you've ever seen.' The only thing I can promise is that I'll try to do the most honest work I can. Well, somewhere along the line the subject either buys that or does not buy that. Ultimately, it comes down to somehow being able to instill confidence. I don't think you can bullshit your way into that, because a lot of these people can see through walls. They look right through you and out the other side."

The Amish gentleman demurred, but his son, Melvin Stoltzfus, agreed. Over the next few weeks word spread and Allard's car became known. Driving around one gray, dreary afternoon, he waved back at some children stringing fences with their father, and stopped. After several hours he had two of his most memorable pictures: the boy shyly presenting his pet guinea pig for admiration, and the small girl pausing pensively beneath the huge muzzles of the massive draft horses. Other images showed young men tugging laughing girls on roller skates down the road in the summer twilight; the hive-like activity of a barn-raising; farmers clustered in bleachers, intent on a horse auction.

After several days of shooting, Allard sent his first batch of exposed film back to Gilka. "It was pretty strange just to drop the film in the mail," Allard remembers. "It was like sending all your stuff to the drugstore. And I wasn't used to not seeing the results right away."

"After looking at eight or ten pictures, you could tell he had the people's confidence," Gilka recalled later. "I've looked at a lot of other pictures of the Amish. They show the dress, the geography, the archaic mode of transport. But they don't have the *sincerity* that Allard got, the feelings, the way these people enjoy life." The results, which appeared in the August 1965 issue, created a sensation among readers and editors alike. They represented a landmark in the *National Geographic* view of a photo story: impressionistic, intimate, with a personal stamp that was unprecedented in the magazine. At the end of the summer, the intern was offered a contract. Six months later Allard was on staff, and he moved his family to Washington.

"The Amish assignment was an incredible stroke of luck," says Allard. "But it turned

*Montana 1966*

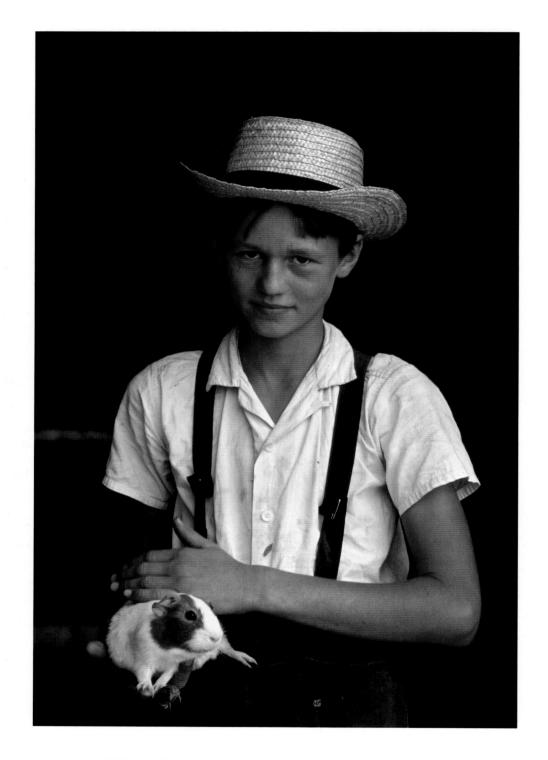

AMISH BOY, LANCASTER COUNTY, PENNSYLVANIA 1964

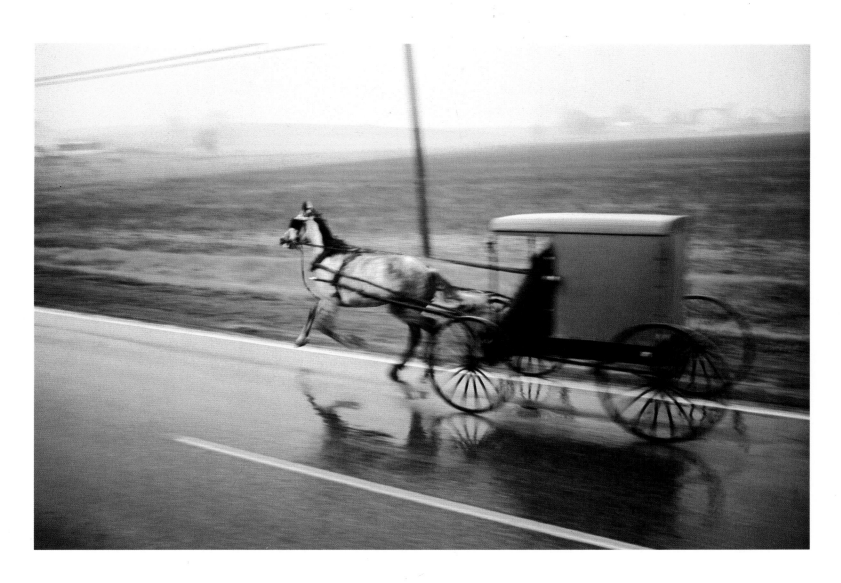

LANCASTER COUNTY, PENNSYLVANIA 1964

out well because I was prepared for it, in my own naive way. I wasn't prepared to do great color photographs, because I didn't know a thing about color. I wasn't prepared to do the ultimate thing on the Amish, because I didn't know anything about the Amish. But I *was* prepared for a subject that had some human resistance to it, one that would take a bit of psychology, as primitive and unknowing as mine might have been." Jon Schneeberger, Allard's friend and long-time picture editor at the *Geographic*, says the ability to overcome this resistance has been with Allard ever since. "He has an unfailing sense of appropriateness," Schneeberger explains. "Of how to get into and out of a human situation."

For the next two years Allard was everywhere but home. He climbed Canada's Mount Kennedy with an expedition including Bobby Kennedy, toured America with Lynda Bird Johnson, and he profiled the city of Houston. At the request of National Geographic Society president and editor Melville Bell Grosvenor, he photographed and wrote a story on winter wildlife in Yellowstone National Park. Even though this was unfamiliar ground for a dedicated photographer of people, he executed the assignment with characteristic aplomb. "Mr. Allard's photographs of the animals are unique and nothing like them has ever been made before," Grosvenor enthused in a memo. "These are extraordinary pictures." High praise from a man who had seen almost two generations of wildlife photographs.

Allard's career had taken off at supersonic speed. But his conscience, ideals, and ambitions made him restless, and less than three years after hiring on at the magazine he resigned. "I feel the time has arrived when I must move on," he wrote to Gilka on August 7, 1967. "There are problems in our country today that cannot be ignored by either the artist or journalist. Although I hope to continue to create images of beauty, I must also attempt to fulfill my obligations as an observer of our society and its conflicts."

"*Life* and *Look* were in Birmingham," he explains now, "but the *Geographic* was still out with the gorillas. It's changed enormously since then, but it hadn't changed by 1967 when I left, and I didn't think it would."

"For a long time Bill thought about going to Vietnam," recalls Kent Kobersteen. "But Smitty [Schuneman] was instrumental in talking him out of it. 'Sure, there are lots of good pictures you could take there,' he'd say. 'You could also end up dead, and there wouldn't be any more pictures to take.'"

"In 1967 Vietnam was really cranking up strong, and there was some heavy-duty stuff going down in the South," Allard says. "I was about to turn thirty, and scared to

*With Robert F. Kennedy, Mount Kennedy, Canada 1965*

death I'd end up at fifty realizing I'd spent all that time in Tahiti or someplace, which is not why I became a photographer. The best solution seemed to be to resign and still work for the *Geographic,* but hopefully to participate in some of these other things, to work for the New York magazines. *Life* had such a significant reputation— *this* was the magazine that was showing the riots, the police dogs, the firehoses—so I thought, well, I'll try to get jobs for *Life.*"

True to form, Allard realized his ambition. In 1968, *Life* sent him to Mississippi to document the start of the ill-fated Poor People's March. In the Delta town of Marks he met the Irbys, a black family that included a widowed matriarch, her daughter and son-in-law, her seventeen-year-old son Hank, and Hank's fifteen-year-old more-than-girlfriend, Ethel Mae. The family of ten lived together in a three-room shack. Still protected by the purity of his motives, Allard spent several hours photographing them. He later wrote:

*By a window in the kitchen Ethel Mae sits smoking. . . . Now, as you take her picture, a brown blur streaks along the edge of the smoke-blackened wall, passing inches from the girl's bare feet to a hiding place behind an open flour barrel. She doesn't see the rat and you don't mention it. Instead you move to another room in this house where human life, goodness and God seem terribly out of reach. And the potentiality of the human race sits in the shadow of a great error, imprisoned and unpardoned by the surrounding flat and gray-pallored fields . . .*

When he left the house, the waiting reporter's face had gone pale; a pickup truck carrying two white men had been cruising slowly back and forth as he sat in the car.

"We were going to meet the Irbys the next morning at the special bus they were all going to take to Washington," Allard says. "We got there, no family. I thought, 'Something's gone sour here.' We drove back out to the house and there was nobody there. So we went on down the road, and this old black man came out to talk to us in the dust, with this inverted *V* of animals trailing him—I'll never forget that. I asked him where the Irbys were, and he said the white boss had come by with a gun. He'd seen them talking to me, and he didn't like that. He told them they'd better get out or he was going to burn 'em out. They scattered like a covey of quail, all frightened and scared and going in different directions. They never did make that bus, and we didn't see them again."

Driving to Memphis under weeping skies, Allard's sense of guilt struggled with his

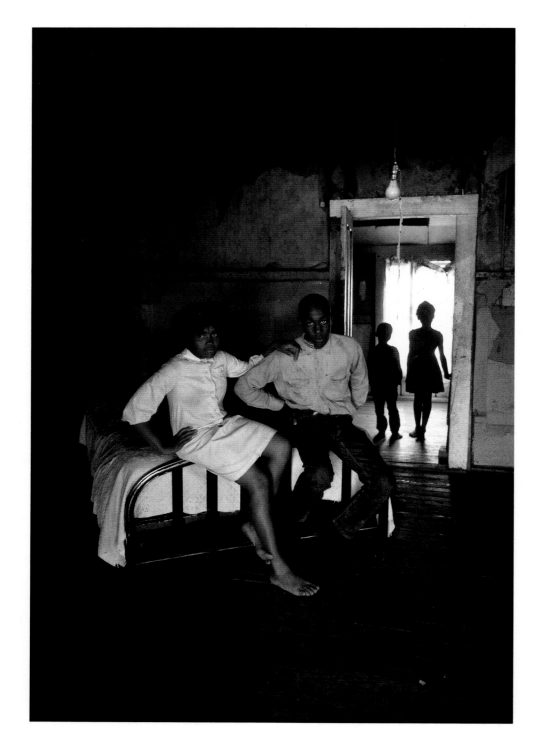

ETHEL MAE AND HANK, MISSISSIPPI DELTA 1968

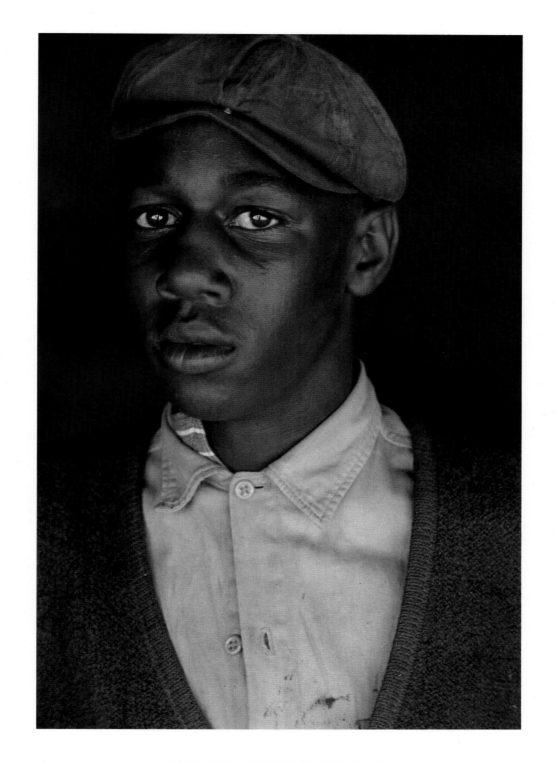

HANK IRBY, MISSISSIPPI DELTA 1968

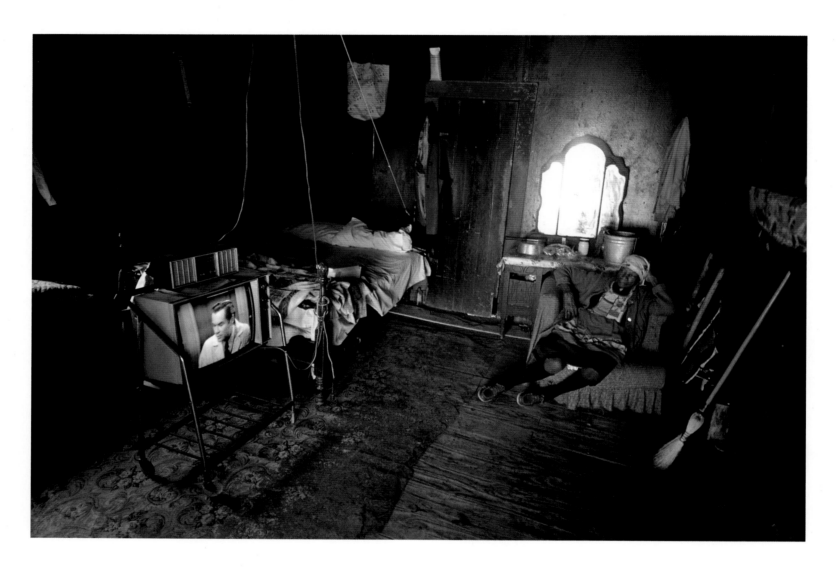

ALABAMA 1970

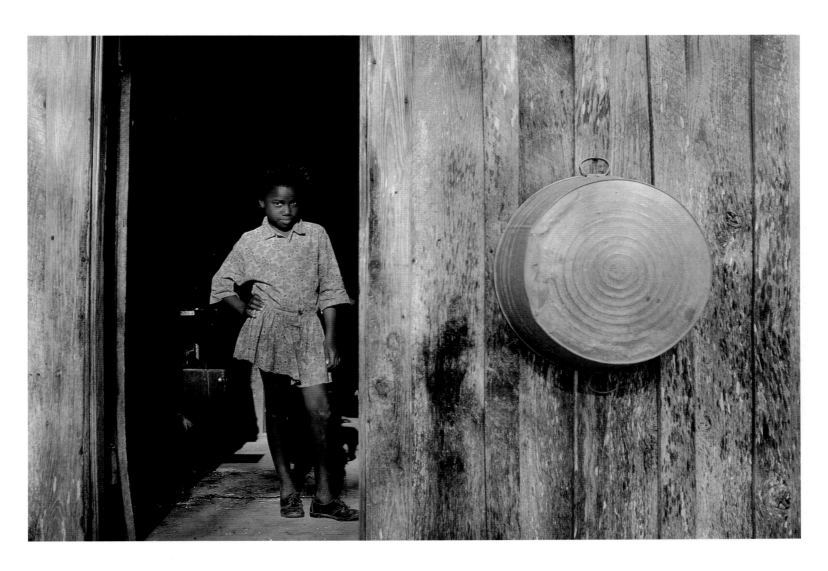

ALABAMA 1970

excitement that he had found a deeper story than the mere illustration of destitution. He thought he might have a chance to redeem his unwitting transgression by telling an important truth, but "I could hear the reporter on the phone to the editor: it was all over," he recalls. "They weren't interested in that family; what they wanted was a two-page spread of the mule train." The experience was a lesson in the often cynical reality of magazine photojournalism, and put his decision to leave the *Geographic* in a new perspective.

In 1967, Allard had turned thirty high in the French Pyrenees, sitting alone in a cafe drinking Izarra, a potent local cordial, and listening to the Beatles singing "Penny Lane." Photographing the Basque country was his first freelance assignment for *National Geographic* since his resignation, and he instantly recognized the region as his. His love of mountains drew him to the harsh terrain and craggy profiles of its inhabitants, proud and independent, with their untraceable language, haunting music, and deep reserve.

Allard spent two-and-a-half months reveling in all of it, its strangeness and resonance. He later wrote, "I think every photographer has a favorite place somewhere. A place where, for a moment in time, his or her work went especially well. Where everything seemed to fit together easily . . . for some unknown reason mysterious and beautiful, you feel at home. For me, that kind of place is the Basque country . . . I think one of the strengths I found appealing about these people is their ability to hang on, to endure . . . ." The Basque people also have, as a caption later put it dryly, a "love of the difficult"—a trait that Allard could surely identify with (see pp. 70–79).

Except for a few dutiful depictions of industry and scenery, the published essay showed more than a place and its people—it showed Allard's emotional response to human situations. In frame after frame there are faces of simplicity and integrity; there is deep saturation of color in moody light; there are unexpected flashes of humor through a scrim of ancient sadness. Allard was indeed at home.

Except that he wasn't. "Many photographers who've worked for the *Geographic* have had problems with their marriages," says Kent Kobersteen. "A picture editor may applaud their commitment, while a spouse would condemn it." Allard acknowledges the problem. "There's a distance between your home life and the assignment that's more than physical," he says. "Sitting on the edge of the Grand Canal watching the historic regatta, going into a wonderful bar where there's great music, your other responsibilities are way behind you."

Three years after leaving *National Geographic*, Allard moved his family from suburban Silver Spring, Maryland, to a rambling house on ninety-two acres of woodland near tiny

Barboursville, Virginia. The move marked the start for Allard of almost twenty years of living in rural Virginia. In this rarefied environment, family members pursued their own interests, but the setting did little to minimize the strain of a husband and father's long absences.

One source of familial pleasure, though, was community theater. The Allards were founding members of a small company called the Four County Players that is still flourishing. For Allard, this experience was more than a recreational diversion, feeding as it did into his natural theatrical instincts. Predictably, as an actor he didn't gravitate toward drawing-room comedy; instead, he played the lead in such forceful dramas as *The Little Foxes* and *Night of the Iguana* and directed *Of Mice and Men*. He often argues convincingly for the similarity in approach of photographers and actors. But he's quick to point out that a photographer can't get what he wants just by playing a role.

Meanwhile, freelancing was proving to be only a moderately successful strategy for the kind of creative freedom Allard was seeking. He returned to the South to photograph for *Fortune*. For *Life*, he covered a coal-mine disaster in West Virginia, and went to Vietnam in 1971 for *Fortune* to photograph, as he puts it, "what we were leaving behind." For the *Geographic*, he photographed the annual "Regatta Storica" in Venice, an event of such calculated theatricality it left virtually no room for him to maneuver. If these were bit parts, however, he was about to get the role with which, more than a decade later, he is still most closely identified: the American West (see pp. 80–93).

"I think it was in me, it was part of me," he says. "I love the space, the independence. The cowboy's got the independence, but he hasn't got anything else. Stan Kendall, sitting there at the end of the bar. Next day he quit. You draw your pay and you leave. I find that appealing." Allard later described the West as "a part of America that just might prove to be the country's soul: a place where myth has long been in partnership with reality."

In a story he wrote as well as photographed on Nez Perce Indian Chief Joseph, he wrote "Montana has always had a special kind of allure to me. Her open space seems to fulfill some inner need in me, like that indefinable rapport that sometimes occurs between strangers. I loved her at first sight and wished I'd met her earlier."

The go-between in Allard's first encounter with the West was *National Geographic*, which wanted a story on the Hutterites, one of this country's surviving Anabaptist sects. (The others are the Old Order Amish and the Mennonites.) The German-speaking Hutterites observe a strict Protestant faith and live communally on ranches in Montana and the Dakotas, as well as in the Canadian provinces of Alberta, Saskatchewan, and

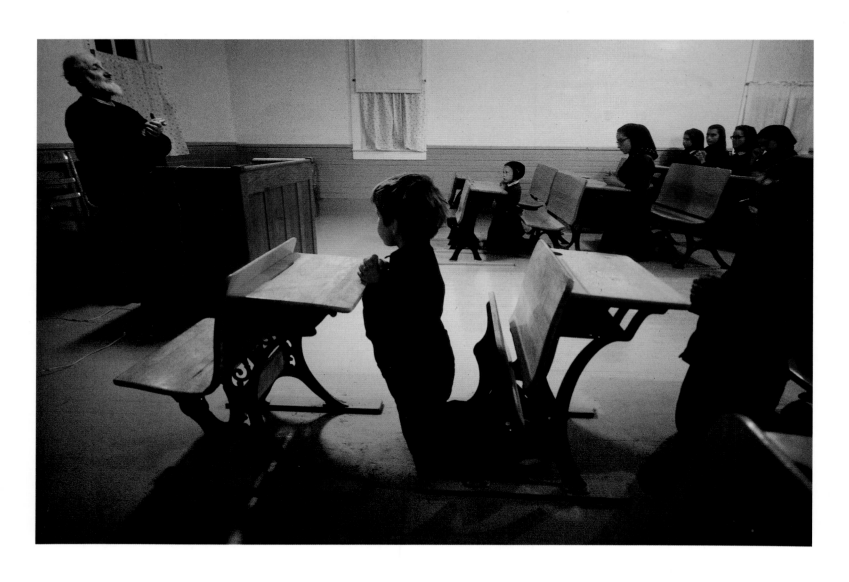

HUTTERITE PRAYER MEETING, MONTANA 1969

Manitoba. Recognizing the difficulty of gaining their acceptance, and remembering his success with the Amish, Allard's editors asked him to scout the territory. He reported to Gilka in a memo dated March 17, 1969:

*During the past week I was able to visit nine Hutterite colonies. . . . At each colony, I passed around a copy of the issue containing the Amish story. This helped a good bit. The copy is now quite tattered. Usually after some talk about the Amish and some verbal tag games with the colony leaders I would end up in the dining room sharing some noodle soup and chewing on a goose leg. Photographing the Hutterites will be a delicate project, possibly more difficult than the Amish—but it can be done.*

Allard spent three months photographing the Surprise Creek and Spring Creek Hutterite colonies. He was asked to write the text as well. His experience with the Amish was some help, but the differences between the two cultures were considerable. With the Amish he could work with individuals who accepted his presence; Hutterite colony leaders, by contrast, exercise complete control over their flocks, so that any misstep might have barred him from contact with every member of the colony.

Most nights, Allard slept at a motel. "Just being there as a photographer was on the edge of the not allowable," he says. "The first time I went to photograph a prayer meeting in the one-room school, nobody showed up. The second time, it was mostly women and children. I positioned myself in just one spot—I didn't feel I could move around. I made just a handful of pictures with one wide-angle lens. And even though I used the Leica rangefinder, which is the quietest camera there is, every time I made an exposure it sounded like a cannon going off."

The pictures don't reflect the difficulties. They reveal, even more intimately than the Amish coverage did, the intensity of the "plain" way of life. The images are warm and intimate: a little boy winces in sympathy with a calf being branded; a man holds a solitary vigil in the lambing pen; young girls decorate candies for a wedding celebration. Allard's text is dense with information, undergirded with a respect for the subjects' rootedness and a sensitivity to the beauty of their lives:

*Later that night a bunch of us sat in a dimly lighted bedroom, sipping cans of cold beer and singing songs about Montana cowboys. One of the women drew a harmonica from her apron pocket and played Red River Valley. A 14- year old girl brought out a guitar she wasn't supposed*

*to have, and while the preacher slept in his house a few yards away, she softly sang a country-western song about young love. The boys teased the girls, and the men laughed at their own jokes while wide-eyed children fell asleep, one by one, slumped in the arms of their parents. There were many nights like that.*

Colony member Paul Walter remembers, "I have never met a man that fit with us so much like one of us."

But for Allard, the importance of the Hutterite story lay less in its pictures than in the scope it gave him to write. For the first time in his career he was in a position to explore the symbiosis between words and pictures that had lured him into the profession. He had written the text for the piece on winter wildlife in Yellowstone two years before, but that was straight reporting on scientific endeavors; plenty of meat, but precious little flavor. If the camera enabled him to explore the world, his battered Hermes 3000 portable typewriter gave him the means to examine more deeply his place in it.

Allard's writing bears many similarities to his photography: impressionistic, with a broader stroke than the typical *National Geographic* story. The details are in the dialogue, rather than in a bland accounting of fact. Allard feels that either medium requires an ability to strip away the extraneous, and an understanding of where the heart of the story lies—probably an unteachable instinct. He also knows that a writer, like a photographer, needs a sense of structure and an eye for color. Being able both to write and photograph a story appealed to Allard's need to be in control. "The chances of a story having a personality of its own are increased if the same person who's doing the photography is also doing the writing," he says.

Allard's words also resemble his photography in that he strives to convey not just the facts but his visceral response to the experience. Allard wrote six of the eight stories he shot for *National Geographic* between 1967 and 1977. After the Hutterites came a story on the U.S./Mexican border, which intensified his feeling for the West. "I was asked if I wanted to do that story," he recalls. "I said yes, as long as you don't want me to make it look like the place to send your kids for the summer." He also made a good case for the value of traveling by motorcycle, and the *Geographic* paid for a Triumph 650, which Allard later bought. In the story he wrote, "The bike gave me a close feeling for the land," but the appeal of the unorthodox approach clearly played its part, too. "That was part of what made it a good story in my mind," he says. Both text and photographs show experience as much as place: they are full of references to individuals,

their struggles and celebrations, and the lure of the unpredictable. "I think he shot every whorehouse on the Mexican border," says *Geographic* editor Wilbur Garrett.

The Mexican-border story opened up more of the West than Allard had seen with the Hutterites. The next step, making a series of pictures for a *National Geographic* book, *The American Cowboy in Life and Legend,* took him even more deeply into it. His magazine story, "Cowpunching on the Padlock Ranch" (October 1973), was a ballad in words and pictures to the remnants of the old cowboy style.

Allard's fascination with cowboy life went beyond the bounds even of his customary intensity. He hadn't returned from Pennsylvania mimicking the Amish, nor had he made any pretense of being a Basque, but he was spotted carrying his saddle through a Texas airport. A case could be made for the practicality of the approach, but it would have occurred to few of his peers. Many of his acquaintances still refer to his "cowboy shtick." He dismisses them curtly, offering a simple explanation for his identification. "There is a dedication there. With the good ones, a dedication to doing things right." There is also independence, a gregarious strain balanced by a need for solitude, tolerance of the impulsive and dramatic, and a rather rigid code of honor.

The West as Allard's creative lode was played out by 1979. But before the end, he experienced both highs and lows. His *Geographic* story on Chief Joseph of the Nez Perce Indians (March 1977) was a skillful blending of words, pictures and sensibility. Here were the vital human elements: struggle, frailty, tragedy. The complexity of the subject—as much about ideas as people—kept Allard remarkably focused. "He didn't make a lot of pictures," remembers Jim Blair, a photographer and Allard's picture editor at the time, "but the ones he needed were there. They really echo the sense of despair that Indians have over the loss of their culture. Even his aerial view of the river valley is right because it's lonely. Allard has that story-telling ability."

It was the mountain men—hunters and animal trappers—who brought Allard down. He presented *Geographic* editors with a convincing case for the validity of such a story, and in executing it used words and pictures to play variations of yesterday and today on the theme that had fascinated him since childhood. Perhaps if he hadn't loved his subject quite so much and identified so strongly with it, he wouldn't have been so devastated when the story was eventually "killed." The passion that drove his previous work may have caused a loss of perspective in this case. "He was so involved with the romance of the mountain men," Wilbur Garrett argues, "that he was making heroes out of what were basically despicable characters." Allard disagrees vehemently with

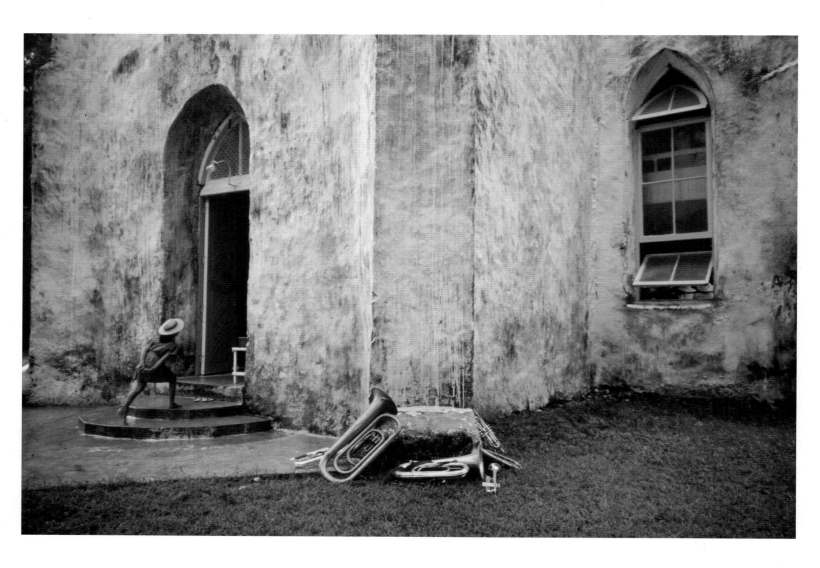

COOK ISLANDS, SOUTH PACIFIC 1966

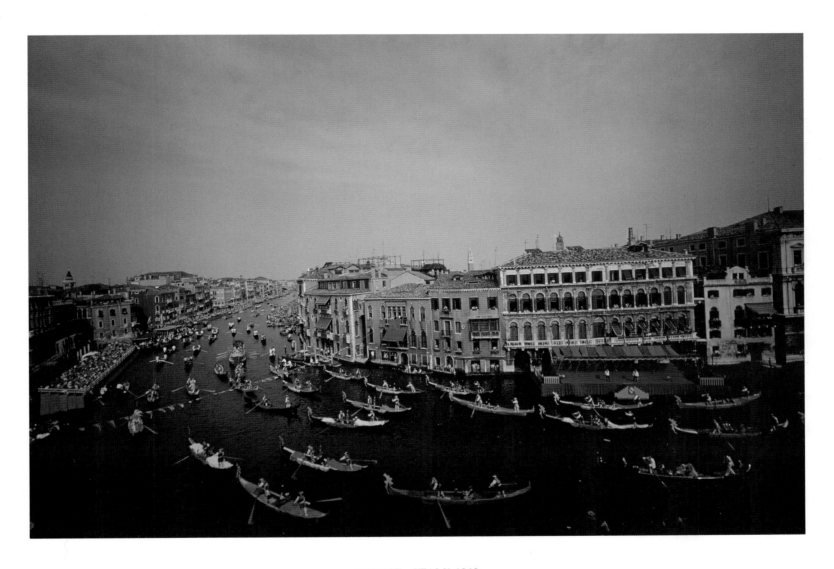

VENICE, ITALY 1969

this view, and feels that the decision not to run the piece was a political rather than an editorial one. The records indicate that the story, its creator, and its demise were handled with notable clumsiness, though every freelancer eventually suffers this kind of disappointment.

However, the disappointment was something of a blessing. "It gave me the ideal excuse to quit writing," Allard says. "I'd been feeling that my photography wasn't growing, and it takes an awful lot of energy to do both. It's like trying to tune in on two different frequencies at the same time. A big advantage to being a photographer is that the published work is more likely to really be *yours*. You can't committeeize a photograph the way you can a manuscript."

Given Allard's penchant for self-immersion, the decision made sense. "With photography, you have to be there," he explains. "A writer, on the other hand—like a painter—can work from memory. Theoretically, he or she can go back to the hotel and sit on the veranda and do it. In fact, the few conflicts I've had with writers on assignments have had to do with my need to be there. I can't go back to my hotel room and *think* it into the camera. The first story I went out to photograph that I wasn't responsible for the manuscript too, it was the most luxurious feeling."

Ideals are the common currency of beginners. Despite occasional setbacks, Allard has managed to retain a good many of his, thanks in no small part to the scope of time and budget—not to mention the generous play given the photographs—provided by *National Geographic*. Indulging one's true passions to the extent that Allard has is as close to pure luxury as his profession allows. But Allard has not spent his career doing only what suited him, and has had his share of less-than-memorable assignments. Among other projects, Allard was called on to shoot additional pictures for a partially completed story on Costa Rica in 1979, and spent a very gloomy couple of months in the U.S. Virgin Islands the same year. "Those were not my idea of a good story," he says bluntly.

Allard did better on a strongly political story about Asian boat people, published in 1979. He also took a stab at advertising work, shooting campaigns for Army recruiting and Marlboro cigarettes. The Marlboro account was short-lived. As Peter Ross Range describes in a 1984 article in *American Photographer*. "The perfectionist in Allard reared its customary head one day, when he shouted at the art director, 'If you want everything *your* way, why the hell did you hire me?' The art director thought it was a pretty good question, and Allard was not invited back onto one of the premier ad accounts."

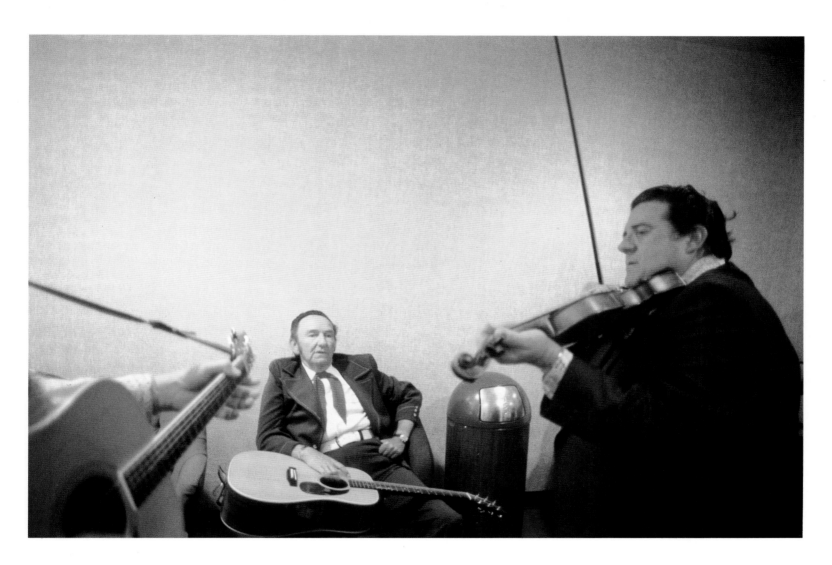

LESTER FLATT, NASHVILLE 1977

In 1980, Allard landed a commercial assignment with few strings attached—a commission from Polaroid to take its money, cameras, and new SX–70 Time Zero instant film and photograph whatever he wanted with them. In the process, he shot lots of 35mm film as well, heading west for a few weeks, then south to Oaxaca, Mexico (see pp. 94–105). Soon Allard got wind of a planned *National Geographic* story on Peru, and although he knew relatively little about the country, he sensed its potential from the feeling for Latin culture that Oaxaca gave him (see pp. 106–121). He recalls, "I kept telling myself, 'I've got to get this assignment. I need to go to Peru.' "

Allard spent five months on assignment in Peru in 1981, working at a new level of intensity. "The country was ten times more than I ever expected," he says. "Peru was just an awesome place. Formidable mountains, impenetrable jungles, some of the driest deserts in the world. They've got earthquakes, mudslides—it's just incredible. You had to tie my hands down to keep me from making pictures. It was a chance to really extend myself." In the process, Allard overextended his budget. By the time he was finished he had shot 1,300 rolls of film, an average of more than eight rolls every day.

In Peru, Allard worked flat-out as long as there was light, and often beyond, intensely alive to every visual and emotional stimulus. He photographed the sweat of toreadors on horseback in searing sunlight and the sacramental reek of slaughterhouses, where young girls lounge barefooted in blood and hewn carcasses take on Picassoesque forms. He shot infant funerals, incense-clouded religious processions, a poverty of brutal and exalted dimensions that recalled for Allard the human plight to which Agee and Evans had reacted in *Let Us Now Praise Famous Men*. Allard's Peruvian work had its own influence: a photograph of an anguished Indian boy surveying the devastation a hurtling taxi had just wrought on his family's small flock of sheep elicited an enormous response from *National Geographic* readers. They donated nearly $7,000, and CARE workers used the photograph to locate the boy, restore his flock, and fund projects in his village.

The experience still gives Allard deep satisfaction. Though directly altruistic motives were far from his mind, he acknowledges a sense of obligation. "As photographers, we're always intruding," he says. "You can't give money to everybody. But this was one case in which a picture I made changed something, made a difference in someone's life. That doesn't happen very often."

The story, called "The Two Souls of Peru," was undoubtedly the high point of Allard's life and career. An equally profound low followed. His marriage ended. His older brother committed suicide. Then, at the annual *National Geographic* seminar in

January 1982, Allard pulled the linchpin out of his career and watched the pieces fly apart.

The *Geographic* seminar is an annual mid-winter event intended to provide inspiration and support to staff, contract, and freelance photographers, and also to give the extended *Geographic* family a chance to socialize. Freelance and staff photographers and picture editors are invited to speak, but an afternoon is set aside to let staffers air their grievances behind closed doors. Allard, unaware that this meeting was for staff only, showed up to take advantage of the forum it provided.

He had returned from Peru in something of a trance state, enthralled by his subject and the intensity of the experience. He was frustrated by what he felt was a lack of receptiveness to his ideas about the structure of the story's layout, and also smarting from what he felt were unjust criticisms of overspending and overshooting in the field. He complained to Gilka. He complained to Garrett. To no avail.

During the staff meeting, as society president Gilbert Grosvenor was responding to staff members' criticisms of new restrictions on first-class plane tickets, Allard exploded. "I don't want to talk about first-class airfare," he said. "What I want to talk about is first-class picture editing." He went on to unburden himself of a number of critical opinions concerning the operation of the magazine.

Bob Gilka was livid. "Bill was pretty obstreperous," he remembers. "Some of the people around him finally quieted him down. But there was a long period after that when we didn't use Allard." Photographer Jim Blair's version of things is somewhat different: "Our general impression was that Gilka said, 'That man will never work for me again.' "

Allard recognized his error immediately. "Funny thing," he says, "when I went to Peru I told myself, 'Allard, it's their magazine. When you come back, let 'em do whatever they want. Forget it.' Only I didn't do it. I let myself pop. I was carrying all this garbage around with me from my personal life. I went out to the seminar dinner that night anyway, but boy, I was like the plague. You could just feel it: 'Don't want to get too close to this guy.' I wept, driving back to the farmhouse. At that time I was living alone. It felt like I'd said goodbye to a lot of old friends."

Allard wrote to Gilka in an attempt to make amends. "I take my work very seriously," he wrote, something Gilka certainly knew. "But I'm realizing that this attitude can be a weakness, because it makes it very hard at times to let go of the work." Allard made several story proposals thereafter, but they were all rejected. Effectively cut off from

his principal client, Allard did little large-scale assignment photography for the next three-and-a-half years. For Allard, who defines himself by his work, this had consequences beyond the financial, drastic as those were.

The *National Geographic* had survived Allard's emotional riptides, even profited by them, recognizing that the impetuousness that could make Allard irritating in a layout session was the same quality that impelled him into situations where important photographs were to be found. "If you had twenty stories in the works, you wouldn't want them all to be by Allard," Kent Kobersteen says cheerfully. "You'd go out of your goddamn mind." Yet he had belonged: there had been long nights of convivial poker, and evenings of music, with Allard playing trumpet and photographer David Doubilet picking the banjo. Allard clearly was banished from much more than a job. The mountain men had suffered what they called "starvin' times." Now he did too.

But these years were healing times for Allard, too. In 1983, he married Ana Maria Baraybar, a young Peruvian psychologist he had met on assignment. He took on several jobs for *Life,* including a story on Ed Cantrell, a Wyoming range detective, and the operation of the Argentine death squads. In 1982 he published his first book, *Vanishing Breed,* a collection of his Western photographs with evocative vignettes he had written; it was nominated for the American Book Award and—unusual for photography books— has been reprinted several times.

Then, in 1985, Rich Clarkson became the new director of photography at *National Geographic.* "The first major thing I wanted to do," he says, "was to bring Bill Allard back." Why? "The images."

Allard's first assignment in the new regime, undertaken in the fall of 1985, was to shoot an Australian phenomenon called the Tea and Sugar Train (see pp. 122–132). Even after his long hiatus from the magazine, Allard was at the top of his form. Clarkson explains, "If you're a thoughtful photographer who simply uses the camera to carry out your ideas, your ideas can march ahead without your having to practice following focus."

The "Sugar," a supply train that travels weekly across the desolate Nullarbor Plain, intersects a highly eccentric population: railway workers, aborigines, kangaroo hunters, diamond prospectors, and assorted misfits. "Allard could see the uniqueness of it," Clarkson says.

In 1986, Allard was back on contract, both for *National Geographic* and *Traveler* magazine, the Society's travel publication. He spent five summer weeks in 1986 doing photographs for a *Traveler* article called "The Sidewalks of Paris," an idea he had

proposed. It's a tribute to Allard's vision that his editors agreed to a story about what may be the most photographed city in the world. But then they knew they would get more than a rehash; they expected and got Allard's interpretation of that city.

Allard was unintimidated by the photographic tradition that Paris represented, and uninfluenced by the Parisian work of such great photographers as Brassai and Cartier-Bresson. "I try not to go anywhere with pictures in my head," he says. The photographs had the familiar formal strength and daring of his previous work, but tempered with sunlight and elegance. The cropped midriff of a *chanteuse*, her arm crossing over her belly and her hand clutching the opposite hip, takes the cliché to task. A couple dances in an outdoor plaza on Bastille eve like a vision conjured up by Ravel's *La Valse*, strings of colored lights forming a vivid and busy background. The spectacle of the city certainly appealed to Allard's dramatic inclinations. "Paris to me was this wonderful, never-ending theater," he says.

Then followed "William Faulkner's Mississippi" (his idea again), which tapped his capabilities even deeper. "Everything that man ever wrote has an underlying river of sexuality and violence," he commented after the first of several ventures into the field. Not content to merely illustrate a literary itinerary of Faulkner's work, Allard searched instead for the fundamental themes underpinning it: the sadness and sensuality; the vulgarity, nobility and narcissism of the world the writer inhabited and created. Here, as in Allard's best work, light has texture, colors have fragrance, and emotions possess an almost physical substance.

As of this writing, Allard is fifty years old, the crucial age by which in the past he tended to measure his progress toward success. "The price is stiff for doing what you want," he says, "and the price is high for the people around you." Some of his friends and colleagues say Allard has mellowed in his middle age. That's possible, but the edge of self-criticism is still useful as the creative scalpel. And the pictures remain, redeeming the mistakes and oversteps that have dogged Allard. "Any one of his pictures," says photographer Declan Haun, "tells you more about humanity than somebody else's entire collection." Rich Clarkson puts it more practically: "His pictures are complicated, but he isn't. You just put him in the right situation and get out of the way."

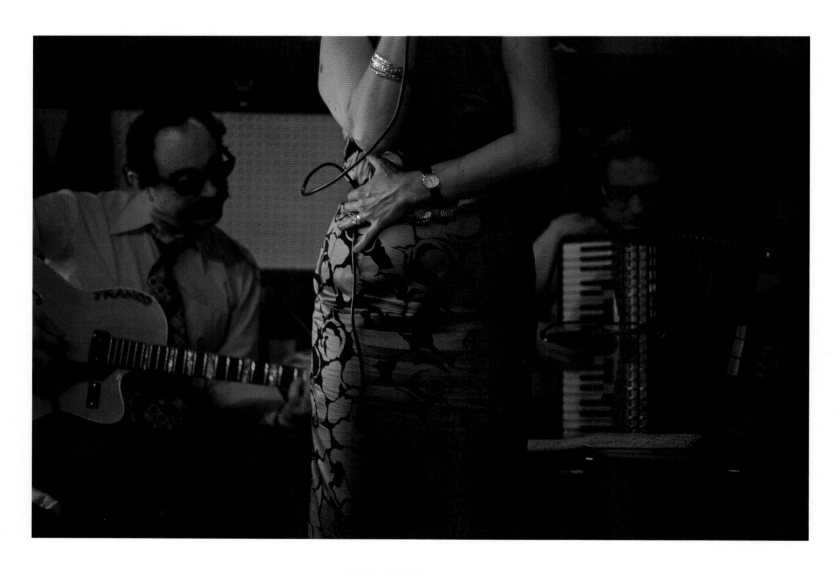

CHANTEUSE, PARIS 1986

STREET ARTISTS, PARIS 1986

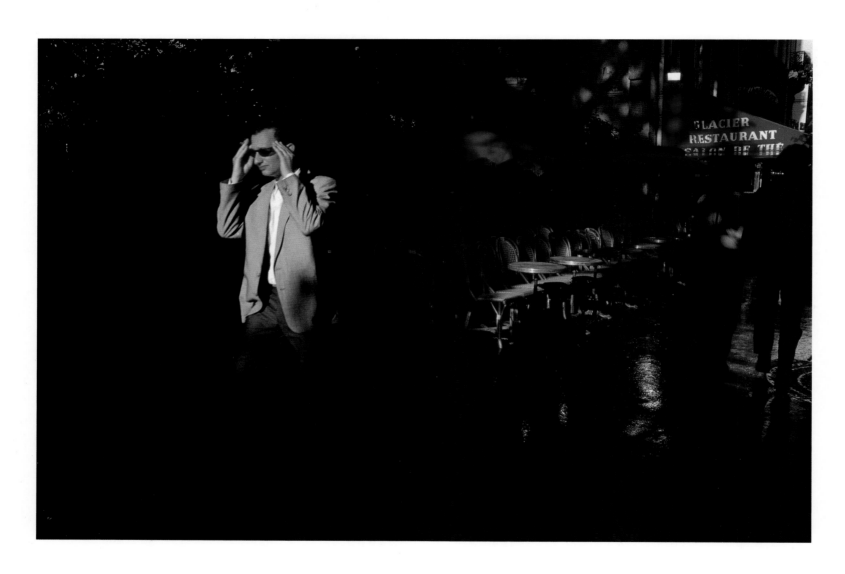

PARIS 1986

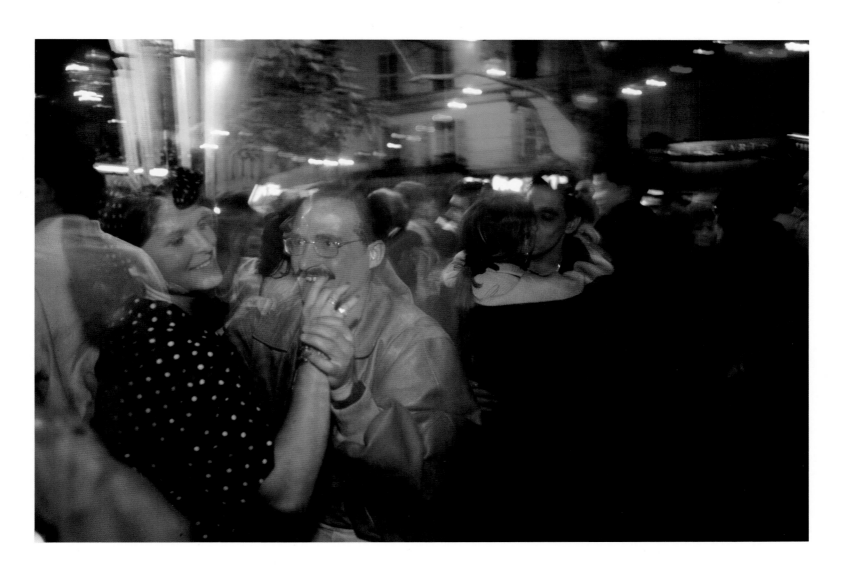

PARIS 1986

FASHION SHOW, SAN JOSE, COSTA RICA 1979

# AT WORK: TECHNIQUE

**B**ill Allard is one of the very few photographers of his generation whose entire body of professional work is in color. Yet when he took his first pictures for *National Geographic* in 1964, he had never worked with color film. In shooting the Amish assignment that launched his career, he used his Kodachrome and Ektachrome as if he were still working in black and white, in low light at wide apertures and slow shutter speeds, which is his preference to this day.

"Part of my style was due to ignorance," he says. "It really never occurred to me that I couldn't do the same things with color that I'd been doing in black and white. It was just more difficult because the color films were much less sensitive—Kodachrome was all of 25 ASA. As I look back, I consider that to have been a great advantage—I didn't know what I wasn't supposed to be doing with this stuff. And because I was forced by the accident of falling in with *National Geographic* to shoot exclusively color, I was afforded a learning experience that I couldn't have gotten anywhere else."

"Black and white is a wonderful material," he says, "but I have no patience for that line of thought that it's more real, more truthful than color. It's absolutely ridiculous, maybe a holdover from the black-and-white heyday of *Life* magazine. I've always felt it's easier to make a picture you can hang on the wall and live with in black and white. You can make a pleasant picture in color, but hang it on the wall and see if you can live with it for very long. With color, you're dealing with a whole other set of problems in making the space work. The red over here may explode and just blow the whole picture apart. In black and white you might have gotten away with that, because the red would end up a middle gray. There's a different psychology to color.

"You have to make these decisions very quickly. That's where I think intuitiveness is the key. I think I can feel color. I can't explain it, but I can feel it. In my photography, color and composition are inseparable. I see in color." John Loengard, long associated

with *Life*, puts Allard's skill and sensitivity in a broader context. "There are very few photographers who've come to grips with color," he says. "Most let it dictate the picture. Bill is one of the few who hasn't been overwhelmed by color."

In fact, the timing of Allard's introduction to color couldn't have been better. It coincided with the beginning of an era in photojournalism in which magazines turned increasingly to color. This trend would eventually see such bastions of black-and-white photojournalism as *Life* switch to color almost exclusively. But at the time, very few serious noncommercial photographers were meeting color's challenge, and the sources of inspiration outside *National Geographic* were slim. "I might've seen color work by Irving Penn or Ernst Haas," Allard recalls, "but I was really more inspired, in terms of color, by painters: the Impressionists, Edward Hopper, Matisse."

Over the past 25 years, Allard's work has evolved not just in terms of composition and content, but in terms of color. Much of his early work is dominated by earth tones. But a vital new palette emerged when he left the western landscape and went to Oaxaca in 1980. Suddenly there was a multitude of red, vibrant purples, brilliant blue and chrome yellow, exotic combinations of orange and green, not to mention a sunlight of a very high wattage.

Typically, Allard views the Oaxaca assignment as a stroke of tremendous good fortune. Not only did it give him the means to be in a place that offered an entirely new, unexplored world of color, but it also coincidentally required him to use a medium—instant film—that provided immediate feedback about the way he was approaching that unfamiliar material.

As Allard struggled to keep the colors under control, his sense of light as a compositional element was evolving. "Over the years I've been trying to learn how to deal with what we tend to think of as 'bad' light—midday light, more often than not. In many cases it's a matter of your really having to confront shadows—hard edges—and make them work for you." His new pictures had knife-like shadows, so much more incisive than the softer contours of the past. A shadow cleaves a Peruvian man, separating him from his backpack. A geometry of darkness isolates the Parisian who pauses on the Boulevard St. Germain to put his sunglasses on after a sudden rainstorm.

If the Oaxaca assignment was, as Allard believes, the ideal preparation for Peru, they were both indicative of an increasingly high tolerance of visual complexity in his subjects. From Mexico onward, in Peru and the Australian Outback, he has been keeping track of more components at a time, giving his pictures, with all their effort at simplicity, a new intricacy.

"I rarely, if ever, preconceive a picture," says Allard. "I don't go out and say, 'I want to make this kind of picture.' But I think over the years I've grown more sophisticated in seeing and putting space together.

"On the other hand, sometimes I've been absolutely *surrounded* by picture possibilities—in Peruvian markets, for example. In those cases, you ask yourself, 'How do I get this? What slice of the pie do I take?' And you'd better concentrate on one slice or you're not going to get any. I think it's similar to a quail hunter's response when that covey of quail just explodes out in front of him. The real quail hunter just doesn't shoot at the covey, he picks a bird. And you've got to do that with pictures."

The Oaxaca work was a departure for him in another, if related, way, in that he was working in a complex urban environment. He had photographed cities before: Houston and Chinatown, two assignments Allard considers less than memorable. But the combination of color and urban culture worked in Mexico to quicken his eye in a new way, an effect due in part to the special vitality of the city. He reaped the dividends in Paris. "I'd never worked in an urban situation in such a concentrated way," he says. I used to be totally distrustful of city stories, but in Paris, there are pictures everywhere."

Not being encumbered with equipment is vital to quick reflexes. "Normally, I won't use a tripod unless I'm forced to," he says. "It's a bit of an awkward tool, and it requires some space and constant adjustment. Also, if you walk into a bar carrying a tripod—well, it's bad enough walking in with a camera. With a tripod you're really attracting attention. I really think you can make your own tripod." Photographer and friend Ira Block remembers a demonstration in a Paris bistro, where Allard braced his camera atop a beer bottle to get the picture.

"Over the years I've done an awful lot of work in marginal lighting conditions," says Allard, "which for me means using very slow, hand-held shutter speeds. I believe there's a parallel between finely made cameras and finely made firearms, particularly sidearms, pistols. People don't do world-class marksmanship with featherweight guns. You need the proper distribution of weight for good balance. That's why I like a camera that's solid, substantial. Not heavy—I don't want to lug around huge amounts of weight. But an ultra-light camera is actually more of a disadvantage. You can carry it from here to China, but you probably can't hand-hold it steady even at a half-second. With a solid camera, you can hand-hold the camera for much longer than people think, but you have to know your own threshold: And if it's a choice between doing that and either adding auxiliary light, which is going to change the environment, or not getting the picture at all, it's worth the risk."

U.S. VIRGIN ISLANDS 1979

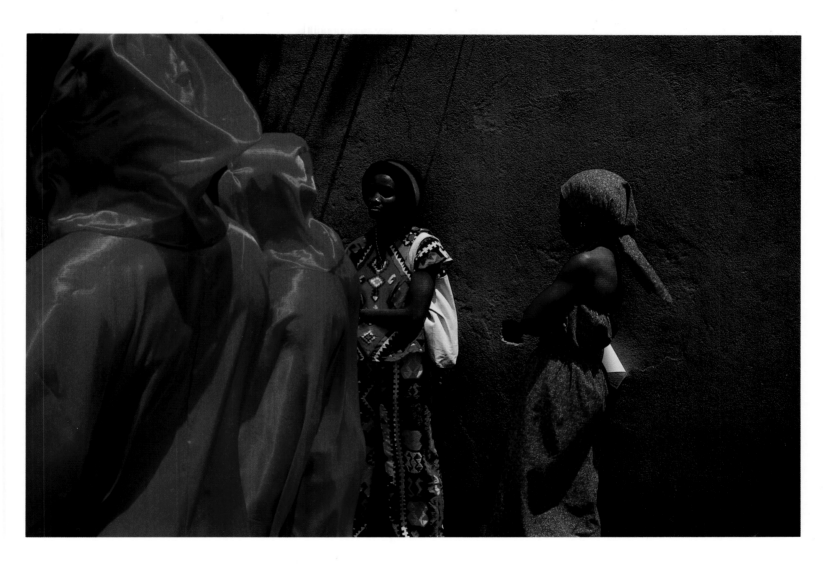

CARNIVAL, U.S. VIRGIN ISLANDS 1979

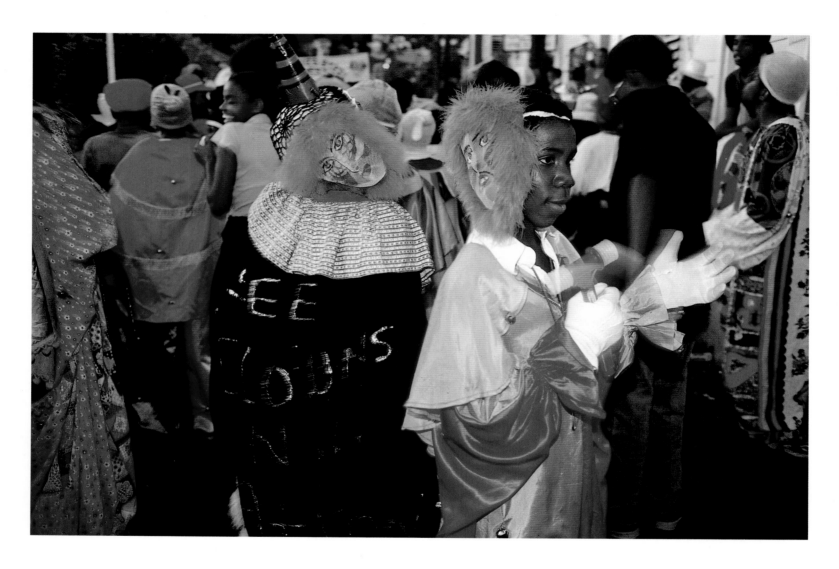

CARNIVAL, U.S. VIRGIN ISLANDS 1979

Allard has something of a love-hate relationship with his cameras. "Theoretically, we should all be able to go out with one camera and one lens and make wonderful pictures," he says. "But the medium tends to turn photographers into camera collectors. Most photographers have more equipment than they really need. When I started at the *Geographic* I used the Nikon F, which was a wonderful, wonderful camera. Very simple, no built-in meter, just a strong, dependable body. You could do anything but pound fenceposts with that camera."

Allard uses a combination of single-lens reflex and rangefinder cameras for their individual advantages. "With an SLR, you're looking at your subject through the optic; you're literally seeing what the picture is going to look like. You have a device that will show you your depth of field, the area that will or will not be in critical focus. This is particularly true for me, because I'm often shooting at the maximum aperture of the lens, the aperture you actually view through. This helps you see how areas of color are affected. It can tell you if that blue has a hard edge, or if it's somewhat soft and blended into something else.

"When you're looking through a rangefinder, though, everything is sharp. The rangefinder window is by and large a focusing and framing device that lets you pick a part of the subject you want to be in critical focus. The only real way you can tell how the rest of the picture is going to look is by experience, or maybe a quick look at the depth-of-field scale on the lens itself. I think the rangefinder frees you up in a certain way. You're probably going to work a little looser in a structural sense, because everything is clean, clear, and sharp. When I look through an SLR, I think I'm a little bit more aware of compositional elements, of the structure of the image. With a rangefinder camera, I'm seeing certain spatial relationships."

Then there are techniques that can only be classified as street smarts. "I was going to photograph a crowd in Lima during a religious festival," he remembers. "I bought a chain and covered it with plastic tubing as a camera strap. That's a little theatrical, maybe, but in a crowd like that someone would have cut the fabric strap I usually use. I've had people try to pull my watch off, and I've been pickpocketed at the bullfights. This time I worked with a vest, too, not a bag. And when I got back to the hotel I discovered that the vest had been slit and I'd never even felt it."

But what makes Allard's stories work is the way he deals with people, not the way he copes with mechanical things, which he views as an unfortunate necessity. And here is where his theatrical instincts come into play. "You're being examined as closely as

your subject is," he says, "and sometimes I think it's better to go right into the middle than hang around the edges ready to run, 'cause they're gonna pick up on that. There's a certain amount of theater involved, when you're trying to get yourself accepted into a situation so you can work. Don't misunderstand—you don't go out and play a part. But if you're apprehensive, you can't really show it.

"By and large, approaching people doesn't really get any easier. You just have to *make* yourself do it. It doesn't get any easier to go into a town where you're a complete stranger, knowing that the only way you can do good work is to establish a rapport. In fact, it gets a little harder. Because there are no tricks, or if there are, I haven't discovered them.

"And you can't bullshit your way through, because often the kinds of people that you want to photograph, or that you need to establish a rapport with, are too sharp for that. They aren't just going to come down the road and express an interest in what you're doing."

The people at *National Geographic*, however, have a considerable interest in what Allard is doing. And Allard's work for the magazine—the bulk of his professional oeuvre—has depended on its extensive support staff, which is one reason why his three-year banishment took such a toll. He was not set up, mentally or logistically, for the daily scrambling of soliciting assignments and—even harder—fulfilling them on short notice in a limited amount of time. Thus there seemed to be some potential benefit in accepting nomination to Magnum, the legendary photographers' cooperative among whose founding members were Henri Cartier-Bresson and Robert Capa. From 1985 to 1987 Allard held nominee status ("I'm the world's oldest living nominee," he would joke), but when he was required in 1987 to decide whether to join as an associate member, he literally could not afford to. So he resigned.

Magnum was founded on an abundance of ideals, and Allard had been welcomed by the membership as "their sort" of photographer. Although the cooperative had gradually veered from its photojournalistic purism to the point where many of its members now depend on it to get them lucrative commercial assignments, Allard's resignation, unlike his earlier departure from the *Geographic* staff, was not motivated by particularly elevated ideals. His name had been suggested for few assignments; in 1986, his work for Magnum totaled exactly two days. Associate and full members must contribute 40 percent of their annual earnings from *all* sources to the cooperative, so for Allard to join would have been economic idiocy.

"I don't like to think about marketing, about how to be a successful photographer

in a commercial sense, because I'm not one," he admits. "My business is just chaotic. I hoped that joining Magnum would help me get organized, which doesn't mean just my office, but my mind, how I organize my time. For example, I have box after box and bag after bag of unedited slides at home—pictures that a stock agency could move if they had them. This has cost me thousands of dollars."

Allard has had occasional representatives (known as "reps" in the trade), but they've rarely done him much good. "I fall into a narrow little niche in commercial work," he says. "I'm thought of as an editorial photographer, a location photographer—someone who can go to any kind of place and come away with images that say something about it, on a documentary level. The advertising business is so literal-minded that no matter what you show them, if the job's supposed to have kittens in it and you don't have any goddamn kittens in your portfolio, you're not going to get the job. There's a lot of big money involved in commercial work, and a lot of nervous people."

In terms of getting commercial work, one of the hazards of being on contract for *National Geographic* is that huge blocks of the photographer's time are spoken for. "Because of the kind of stories the magazine does, you're basically inaccessible for long periods," says Allard. Being unavailable can be the kiss of death for a photographer seeking the kind of short-term freelance work that sustains the industry: if an art director can't get hold of his first choice, he'll go with his second, and be less inclined to call on the first choice the next time. Though frustrated at times, Allard hardly seems heartbroken by this peculiarity of life with the *Geographic*. "Commercial work is good money, but it's just not very interesting. A lot of photographers get the attitude that they can't afford to do editorial work because the pay is so much lower. I feel I can't afford *not* to do it."

*National Geographic's* more relaxed way of thinking about a photographer's time is one of the things that distinguishes it in the magazine world. Given two weeks—the most time a major *Life* story would ordinarily receive—instead of three months to complete a country coverage, for example, "there's no way you can physically cover the same amount of ground," says Allard. And without the give-and-take approach that having lots of time allows, Allard's ability to "penetrate the bedrock," as his friend and picture editor Jon Schneeberger puts it, is lessened. "My work habits have been influenced very much by the fact that my main publisher is *National Geographic*," Allard says. "*National Geographic* is without question the world's finest vehicle for a still photographer who wants to do documentary work."

The loss of opportunity caused by the magazine's demands is partially offset, at least

HONG KONG 1979

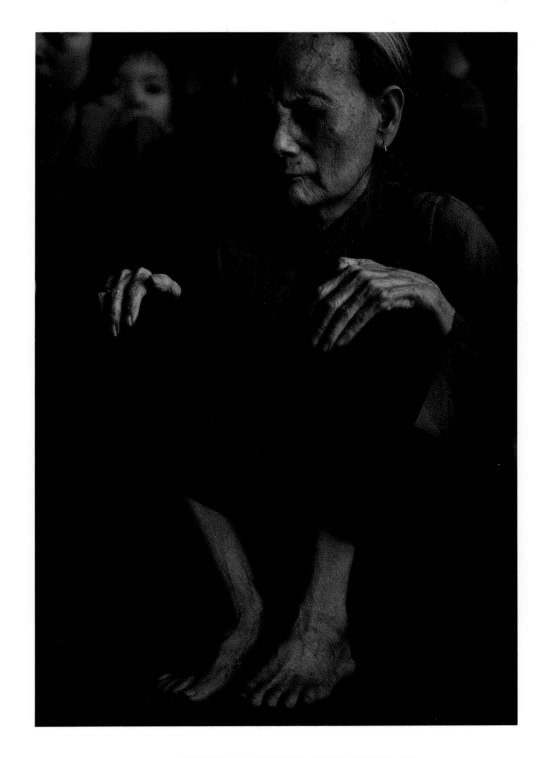

SOUTH VIETNAM REFUGEE, HONG KONG 1979

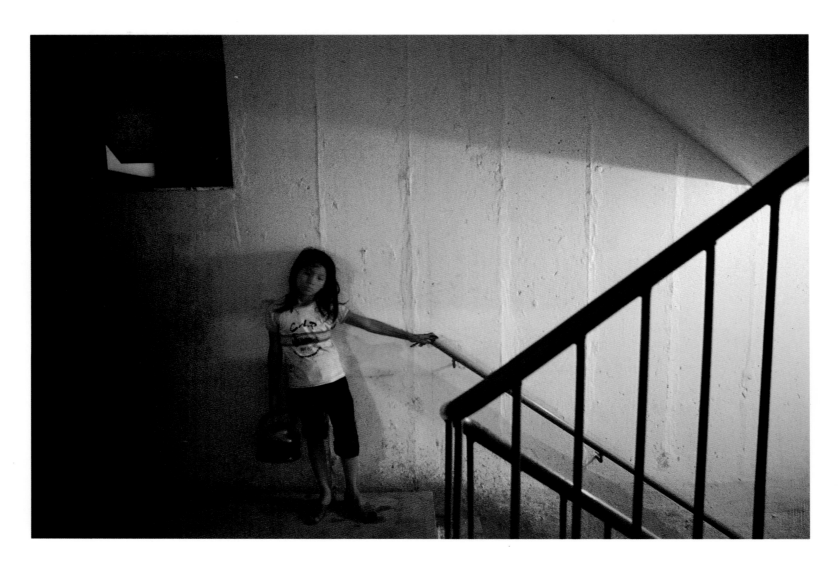

SOUTH VIETNAM REFUGEE, HONG KONG 1979

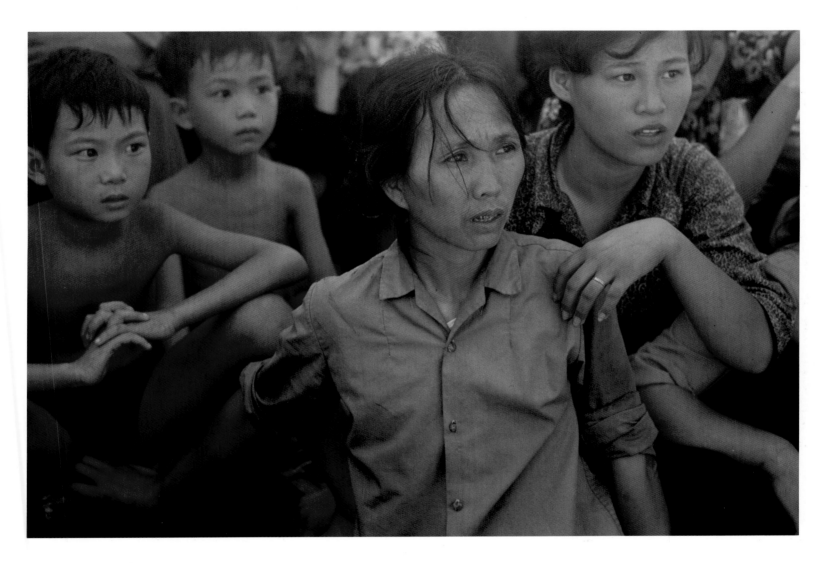

SOUTH VIETNAM REFUGEES ARRIVING IN HONG KONG 1979

in financial terms, by the current arrangement Allard has with the *Geographic*—that of contract photographer. A contract combines some of the security of being on staff with some of the freedom of freelancing. In effect, it's a retainer: the photographer is guaranteed work for a specific number of days per calendar year, at a fixed day rate—currently, $350 to $450 a day.

Within limits, contract photographers can negotiate their own deals, choosing the number of days of work they want a year. Most choose 150 days or more; this year, Allard has the smallest contract of any *National Geographic* photographer, 130 days, which reflects his desire to leave a lot of time open for other things. "This way, I'm available to work on other projects that I might not be able to do for the *Geographic*," he says.

In the absence of commercial work, a photographer who wants to do serious editorial work must generate ideas rather than wait for them. Allard, for all his success, is no exception. "Today more than ever, it's the idea that makes or breaks you as a photographer," he says. "I've had a lot of success getting my ideas accepted, by *National Geographic* or other magazines. Half the battle is writing a good query letter. You have to remember that you're addressing it to an editor who will be besieged by a million other people who all think they've got the greatest idea in the world, and his is just the magazine that should do it. And you have to know what the publication has previously run that has anything in common with this wonderful idea you've got, because if it repeats a fairly recent piece, they won't go for it. At the *Geographic*, you have the advantage of being able to refer to its published index, which lists everything by subject.

"A query shouldn't have any gloss or flamboyance to it. It should get right down to the basics, and it shouldn't run over a page and a half. You should be able to sell any idea in that amount of space. As for *National Geographic*, I've had good luck with my queries when my relationship with the magazine was good. When my relationship was bad, I could've had the inside story on Christ coming back next week, and they wouldn't have touched it."

# AT WORK: MISSISSIPPI

Oxford, Mississippi. Home base for William Faulkner, and base of operations for William Allard at work on a story about Faulkner for *National Geographic*. The dogwood is in blossom, the pecan orchards raise bare hieratic arms, and remnants of last year's cotton flutter like lint across the Delta's furrowed fields. The photographer-as-hunter analogy is amazingly apt here, for Allard in the field is essentially tracking his pictures by their spoor. Some photographers work off a check list of mandatory people, places, and things that comprise a story, an approach that has a noble precedent in the Depression-era work of the Farm Securities Administration photographers, who were given "shooting scripts." But the best of these photographers managed to go beyond the preconceptions of such a method, and the people at *National Geographic* know better than to cramp Allard's style this way. "I got maybe one list in my career there, then they turned me loose," he says.

Instead, Allard relies on what could best be called—odd, for a visual medium—a practiced sense of smell. He does keep a notebook in which he continually scribbles names of people to see, and small towns to visit—places with curious artifacts or phenomena. He notes "sacred harp" singing, fife-and-drum corps, antebellum mansions open to the public at special times, a small barbershop glimpsed in passing, a baseball field—locations of particular interest to Faulkner the writer and Allard the photographer. He has also compiled a list of phrases from Faulkner's works—"the day dawned bleak and chill," "the small girls climbing trees"—and motifs—sister/brother, country doctors, mules. "There have to be generic pictures," Allard concedes, "but even these grow out of specific places and situations that attract me to begin with. I know I won't get good pictures if I start by thinking, 'I want to go out and find a poor white family that seems to fit into this novel or that one.'

"When I begin an assignment, I'm a little afraid, and not really sure just where to

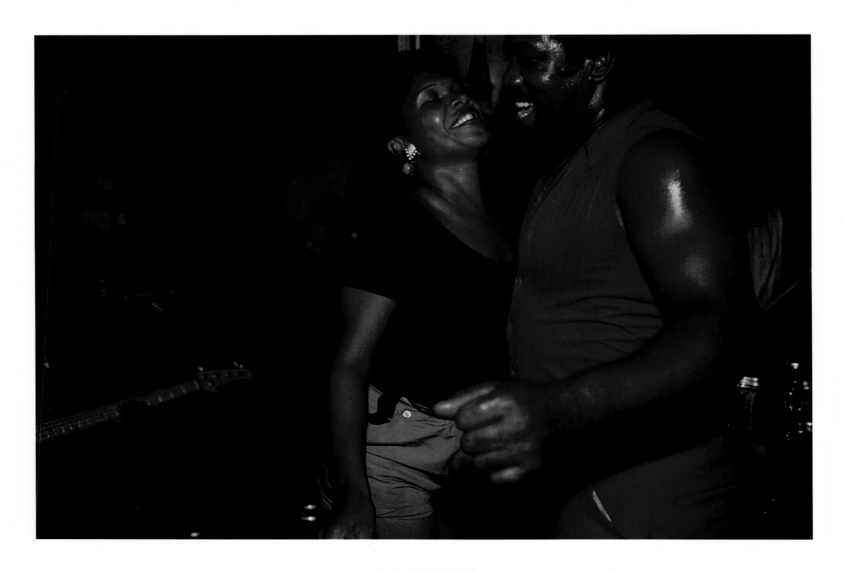

MISSISSIPPI 1987

begin," Allard says. "Research is important to a degree, but I try to start a new project with an open mind. Too many impressions gathered from the experiences of others will sometimes get in the way of the freshness I hope for. I like to explore, to be sensitive to the rhythms of the moment. Exploration means seeking out what I *think* is there, and yet often finding something finer, something closer to the center, that no amount of research could have led me to. But when this happens, it happens because I allow it to. All I need is my brain, my eyes and my personality, for better or worse."

In fact, he needs somewhat more than that. As his equipment comes off the airport conveyor belt, it looks like a lot but is actually the bare minimum. To spend three weeks in Mississippi, he has packed the following into several battered Halliburton cases and a few soft bags:

—Four single-lens reflex bodies (all Leica R4s)

—Two rangefinder bodies (both Leica M6s)

—Eleven lenses, seven of them for the SLRs:

   a 19mm ("almost never use it")

   a 24mm ("use rarely")

   a 28mm ("sometimes")

   a 35mm ("my workhorse")

   a 50mm ("I use it more and more")

   an 80mm ("as long as I usually need")

   a 180mm ("sometimes")

   and four for the rangefinders, a 28mm, 35mm, 50mm and 90mm

—Three flash units:

   1 Metz handle-mount

   1 Vivitar 283

   1 small Mecablitz hotshoe-mount

   and a few small "pocket" strobes

—One small Tupperware box with a square hole cut in the lid, to fit over the strobe head as a diffuser

—Film: "I brought more than I figured I'd use: a couple hundred rolls of Kodachrome 64, a couple of bricks of Kodachrome 200, and a few rolls of high-speed tungsten Ektachrome."

—One tripod ("I should use it more.")

—Extra batteries

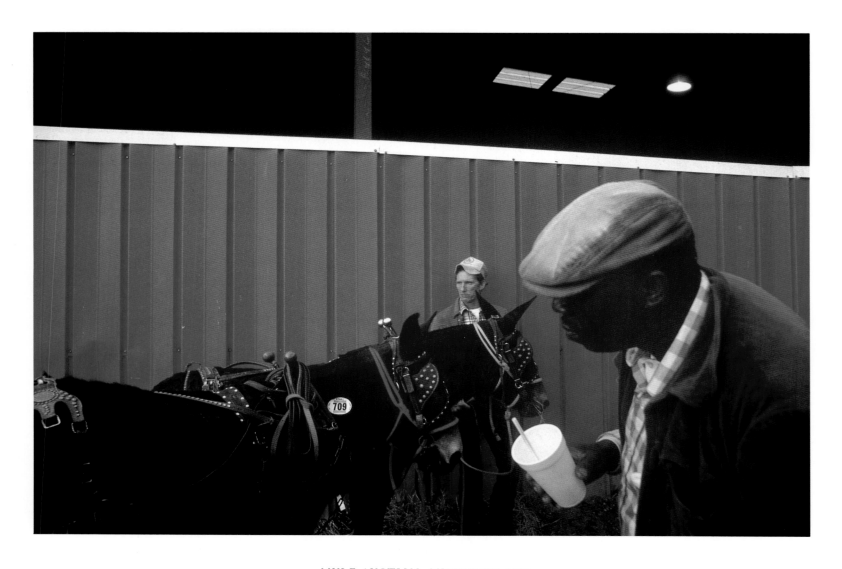

MULE AUCTION, MISSISSIPPI 1987

—Several felt-tip pens for labeling film canisters

—Caption books

—Expense report books

—A small library of books by William Faulkner

—Not to mention five hats, nine pipes, one-and-a-half pounds of Royal Viking Plus tobacco, and a fifth of George Dickel bourbon whiskey.

Allard apologizes for the overkill. "Most of the pictures I take, and that I've had published, could be made with one of two or three lenses—pretty much in the 35mm–50mm–90mm range. But you might need that special wide-angle or long lens on occasion. The longest lens I own is a 400mm, and I haven't taken it on assignment in over two years." It says something about Allard's sensitivity to light and his preference for marginal lighting conditions that he owns three 50mm lenses for his rangefinders: an f/2, an f/1.4, and an ultra-fast f/1 lens, a considerable piece of glass in which the maximum aperture measures two inches across. "Much of my work is done at maximum aperture," he says, "and even then, in the Hail Mary range of slow shutter speeds."

Hardware aside, photography for Allard is not so much a matter of taking pictures as *realizing* them. Pursuing his picture involves a process that Allard admits is "almost 100 percent intuitive. I tend to wing things a bit," he says. How does he recognize a picture? Unthinkingly, he offers a photographic metaphor: "You get a little bit of a clicking in the gut," he says. Perhaps more significant, he also recognizes when the pictures are not happening, which is too often for comfort. When he realizes he's missed a good opportunity, he turns the intensity that would have been devoted to the picture on himself. An emotional trapdoor drops open and he plunges into rage and frustration, accepting no excuses and mitigating no circumstances.

He has been trying, for instance, to get permission to photograph inside Mississippi's Parchman State Prison. But as he drives back to Oxford from Memphis in a thunderous purple-black downpour, it doesn't occur to him—as it wouldn't to any ordinary person—that the prisoners might be sandbagging the riverbanks. When he hears the next day that they were doing exactly that, he lacerates himself for not having thought of it. At such times, he tends to lunge for the phone to agonize to friends or colleagues about his failure, his obtusity, the loss of an irreplaceable opportunity to make an incredible picture. "*I should've been there,*" he will cry. "Why the hell didn't I think of it!" (He grabs the phone in elation, too; Smitty Schuneman remembers being awakened more than once by an excited call from Peru.)

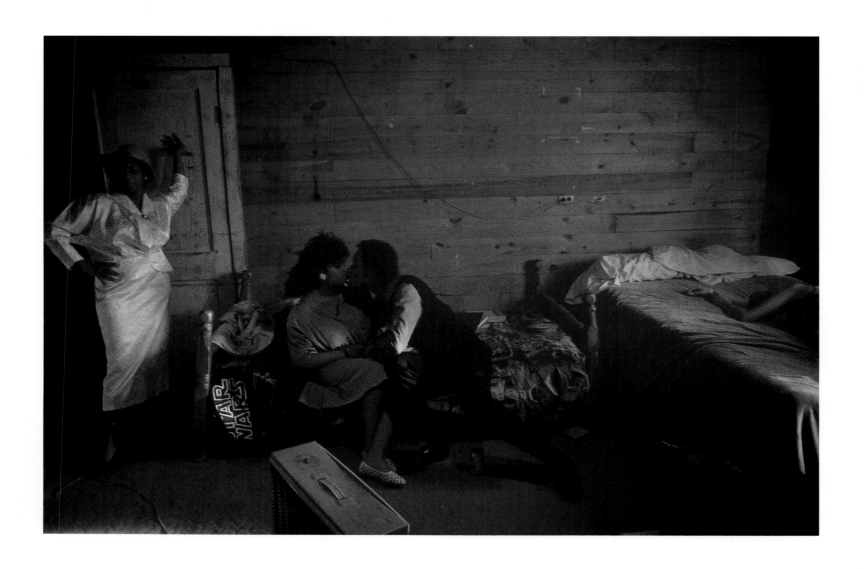

MISSISSIPPI 1987

Late Saturday afternoon in Mississippi Allard sets out for Holly Springs, thirty miles up Route 7 from Oxford, to the Alley, a neighborhood where black men mingle in groups outside Crawford's music store, watching their friends cruise by slowly in their cars. Though Allard might have gone on his own, he has taken advantage of the entree provided by Billy Cochrane, a young white man who runs a small music store in Oxford, and who knows Crawford. The immediate purpose of the visit is to ask about any good live music that may be underway somewhere nearby, but the larger aim is to be seen and become known. Meeting Crawford, making a contact, gives an unspoken imprimatur to Allard's presence, just as being befriended by farmer Melvin Stoltzfus eased his way into Amish society more than twenty years earlier.

Desultory conversation as people come and go; Allard is nonchalant, low key, testing the environment. He knows that the main purpose of this first visit is not to find something to photograph, but to submit to the investigative sniffs of the territory's occupants. His camera is on his shoulder, but before he even tries to use it he wanders across the street to buy a few six-packs of beer. He offers them around and cracks a beer himself.

"If a subject has a delicate surface to it, you don't want to just go charging in there. You need to establish some kind of presence and understanding," he says later. "But it's established early on: I'm a photographer. I take pictures. When I'm around, there's a good chance I'll be taking pictures. But my subjects aren't used to seeing someone who is *always* taking pictures. Hopefully they'll get over that eventually. I will say, 'Try to forget I'm here. I won't ask you to pose, I won't ask you to do anything.' It's important that I just be allowed to be around, to be present."

Quietly, intermittently, he begins to take a few pictures, but not yet of any people. He photographs a scribbled announcement tacked to the doorway, glowing in the molten light of the setting sun. He photographs a pair of shiny workshoes left on the brick windowsill next to the rusty Coke machine, easing slowly past it to include unobtrusively a few of the bystanders. But the situation is amorphous, incoherent, and he can sense that there aren't any photographs about to happen here. "Sometimes the light's there," he says regretfully, "but the picture isn't."

When the picture *is* there, light often makes this Allard's most productive time of day. "In the afternoon, the light just gets better and better," he explains. "But there's no such thing as 'bad' light; some light is better for certain things. Early morning light is probably the least useful—and you have to get up at that ungodly hour."

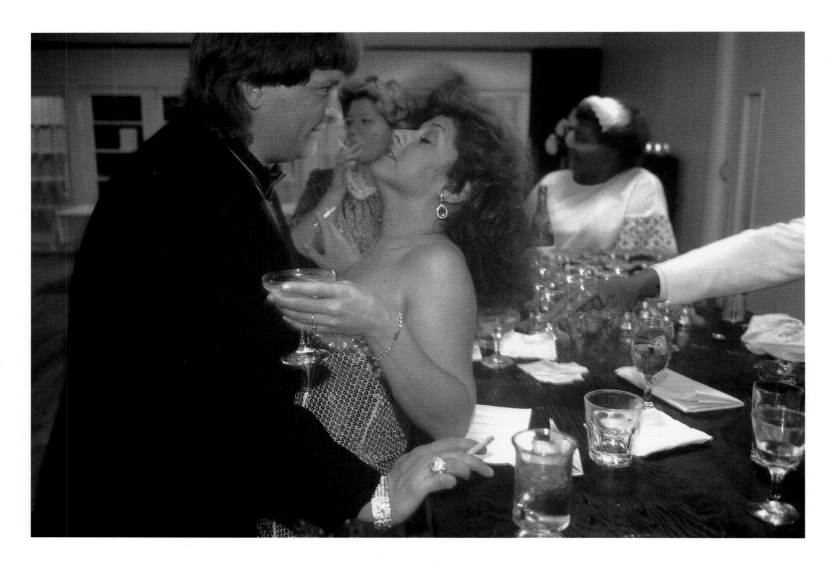

MISSISSIPPI 1987

The next morning is Palm Sunday. Looking for higher emotional voltage, he goes to services at the Second Baptist Church, with its almost all black congregation. Dressed in sport coat, tie and cotton slacks, he is very respectful in asking the pastor's permission to photograph. But because of the anticipated size of the congregation and some bad experience with photographers, the minister stipulates that Allard stay in one spot. He agrees. "We don't have a license to do anything," he says later. But he also senses that this situation is not going to heat up enough for good pictures; or if it does, that he won't be able to get at them.

He does manage some glimpses: a child, numb with boredom, lapsed against his mother's shoulder; the detail of an usher's black-sleeved arm across a woman's fuchsia back; a cluster of girls in a balcony pew. But this is just what he calls "using the camera as a sketchpad," and the results in this case are merely good pictures; despite expressive color and interesting composition, they're little more than still lifes. Prevented from getting closer, physically or emotionally, he's not connecting here. But he senses that if he could find a place where some powerful music is being made, both he and his subjects would come alive, opening the way to the images he wants. "I get fed by music," Allard says. "I'm very audio-oriented."

Toward the shank of the afternoon he and Billy Cochrane find their way outside Holly Springs and down a rutted driveway to an impromptu blues session at Junior Kimbrough's four-room house. Kimbrough is patriarch of one of the two main local blues groups, and Sunday afternoon usually finds a variety of musicians at the microphone in his living room, with tides of friends ebbing and flowing. Cochrane and Allard watch the dancers, and they stand around the tiny porch drinking beer, corn liquor, homemade wine. The scrofulous wallpaper is peeling, the sofa little more than a Naugahyde carcass. It's immediately clear that things are going to work for Allard. He is quickly accepted. "Allard has an unfailing sense of how to get into and out of a situation," says Jon Schneeberger. Cochrane puts it more poetically. "Bill reminds me of the Zen koan: 'Entering the water he makes not a ripple/Entering the grass he moves not a blade.' " Underlying all Allard's skills and good manners, what eases his way into so many disparate situations is his complete attention to the moment. No distracted glance, no distant reply; he's not a visitor, he's *there*.

Allard can feel the pictures happening. There has been no resistance to his presence (as the afternoon and liquor flow on, many of the people here would have trouble resisting gravity, much less a photographer). He photographs Junior's wife, who sits for hours

on the bed gazing out the closed window, the light softly discovering her face. He crouches in the corner behind the drummer for a different angle on the solitary figure of Junior playing the guitar. He returns to the bedroom to photograph a couple sitting and talking with an air of ambiguous intimacy. He goes out to the porch to joke and drink, passing the jug of home brew and lighting his pipe for the hundredth time. Back into the crowded living room, where the light has dropped below even the "Hail Mary" range and the yellow overhead bulb has been turned on, to photograph the dancers again. The music is louder, the air heavier; the emotional elements are getting tangled, the visual components more complex. "He might go into a situation where I wouldn't take a picture," says fellow *Geographic* photographer Ira Block. "Too dark, too confusing, too complicated. But he'll work that situation. He'll have a lot of bad frames, but he'll get the pictures."

Six hours and fifteen rolls of film later, Allard closes his camera bag and slips away into the night. "I need three years to do this," he groans. The next day he doesn't do much of anything.

Allard has been sending his exposed film back to his picture editor twice a week, in the *Geographic*'s own reinforced mailer—naturally, a bright yellow box. Shipping film regularly is one luxury of shooting a domestic story; it's much harder in a foreign country, particularly one with primitive communications systems. Being in the United States also means that he can get through to his picture editor by phone more readily, provided the editor is in his office. If Allard can't find him there, he has no qualms about calling him at home, at any hour. The picture editor is too vital a link for the photographer to let etiquette stand in the way of reaching him, particularly given the long-term nature of *National Geographic* stories, in which a photographer may not see any of his film for several months. The picture editor is the photographer's surrogate for his own eyes— at least until he returns to Washington.

"In most cases, you feel it when you're doing something special," Allard remarks. "It shouldn't jump up and surprise you. But the picture editor is there to confirm that gut feeling, and to assure you that you're not tripping yourself up technically."

Actually, once the film is logged in, sent to Kodak for overnight processing, and returned in the familiar yellow slide boxes, it spends a day or two in the offices of the film review department. Film review serves as an initial technical check, to make sure the photographer's equipment—both mental and physical—is functioning properly. ("You have a pinhole in your shutter. You have some garbage in your camera that is

affecting the results. You're tending to shoot a stop over, or stop under.") "Their function isn't really aesthetic," says Allard. "But they sometimes give me an initial opinion of the quality of the work, before the picture editor sees it. Sometimes this is crucial, because a picture editor can be juggling as many as ten stories, and he may get hundreds of rolls behind on yours. If you don't have any feedback, you're stalled." But true to form, Allard's trust only goes so far. "I find that if I get really good reports," he says, "it makes me a little suspicious."

Once the picture editor gets to the film, he starts to cull the strongest pictures—ideally, images that work both visually and informationally. Picture editing at *National Geographic* is very much a matter of personal style: some editors are more "liberal" (Allard's word) than others, pulling many more slides from the thousands of exposures.

Regardless of who's editing his story, Allard goes straight for the yellow boxes when he returns from the field, looking at every frame he's shot. "I do it to get the depression out of the way," he says. "To see the mistakes." Over the course of the editing process, he will often retrieve pictures from the work that didn't make the editor's cut, but usually just to compare a frame to a similar one that the editor might have chosen. "It's unreasonable to expect an editor who's under all kinds of deadline pressure and working on other stories to bat 100 percent," Allard acknowledges. "Yet with a good editor, I rarely find anything in the yellow boxes that he's missed."

Although these days it seems that a *National Geographic* picture editor's first mandate is to choose images for their aesthetic quality, he must be very sensitive to the story's content and approach. Some picture editors may join the photographer on location to get a feeling for the material, an experience that should, in theory, strengthen their ability to edit the story effectively. Some picture editors will even scout a location for a photographer—a practice that, surprisingly, doesn't seem to rankle Allard. "Picture editors at the magazine have never told me what I should do. I've been directed by picture editors of other magazines more than by picture editors at *Geographic*."

A picture editor also depends on the photographer's caption books, which include carbons that can be snapped out and enclosed with a shipment of film. "I'm afraid I make my captions fairly brief," says Allard. "They're not all-inclusive—probably a lot less informative than the average newspaper cut line. If they decide to run a picture and I don't have all the information they want, then the research department follows up on it. It's nice to have that backup, and not have to worry as much about the details when you're shooting."

Ultimately, the picture editor's task, working with the photographer—and Allard is there every step of the way—is to reduce the thousands of slides to a tray of no more than eighty "selects." Often, in the middle of the editing process, a meeting will be held with photography director Tom Kennedy and/or Kent Kobersteen, the assistant director, to take stock of the story. Then a screening is held for editor Wilbur Garrett, attended by representatives from illustrations, editorial, cartography, and legends. The legends department writes the captions, and Allard is concerned because he feels that the Faulkner captions will require a particularly deep and subtle understanding of the material.

If Garrett thinks there's enough material to complete the story, his nod sets the wheels of publication in motion. The next step is to make a dummy of the article—a rough layout in which the pictures are sequenced and arranged with text blocks. At *National Geographic*, remarkably, the photographer is invited—even expected—to participate in the layout sessions. Allard has a few reservations about this process, stemming from the fact that the layout is done against a large wall, using black-and- white conversion prints. "The magazine isn't black and white, so you can't tell how colors are going to play off one another," he says. "Some color pictures just can't be neighbors. And the magazine has a gutter you could hide a family of five in. You don't see how much of the picture will disappear into it when you just tack it on the wall." But Allard graciously acknowledges the extraordinary degree to which the photographer is included: "I don't think there's any other magazine that allows the photographer so much participation."

It's been several months since Allard was last in Mississippi, and he's back in Washington in the dead of winter. The annual *National Geographic* Seminar—the event at which he excommunicated himself from the magazine six years earlier—starts in two days, and it's a measure of his renewed acceptance in the *Geographic* family that he will be a featured speaker at it. He's putting together a slide show of his recent work, including Mississippi, for the presentation.

All his Mississippi film has been processed, and Allard and his picture editor, Jon Schneeberger, have reduced the work to a tray of slides. Over the years, Schneeberger has edited some of Allard's most important work, starting with a part of the Basque story and including the Hutterites, the Mexican border, and the mountain-men story that never saw ink. Tomorrow morning he and Allard will give editor Garrett a screening of the cream of Allard's Mississippi crop—a slide tray's worth, out of which some twenty

or twenty-five images will probably be used in the story. Garrett is a busy man, and a session with him is typically a whirlwind affair, so Allard and his editor have to be well-prepared. Last time they met, they culled seventy-six slides from the heap, but Schneeberger has since gone back into the slides that didn't make the final cut, substituting them for some that did. The two men sit in a darkened screening room across from Schneeberger's office, Schneeberger ragging Allard in fun every time he lights his pipe, the flame flickering across the screen. A few slides into the tray, Allard speaks up.

"What were you reading?" Allard asks.

"About three books at once," Schneeberger answers.

"You can read three Faulkner books at once," says Allard. They laugh. Schneeberger pushes the button on his remote control and a new slide appears on the screen, a simple image of a maple tree, its fallen leaves blanketing the ground in gold. A church peeks through the richly foliated background.

"I threw this out, then put it back in, then threw it out again," says Schneeberger. "Too bad it's a maple tree, because he talks more about oaks."

"That's the church Faulkner was married in," Allard explains. "Let's keep it—a surprising concession from a photographer who ordinarily balks at the notion of a programmatic picture story. But Allard challenges Schneeberger's inclusion of a sweeping landscape bisected by a receding road. "I don't like this picture, Jon. It's dull. I've told you that all along," he chides.

"But it's *outdoors*," pleads Schneeberger. "We need more outdoor stuff. Outside is where he wrote his books . . . the imagery of the outside."

Allard agonizes over a scratch in a slide of an Ole Miss coed at a fraternity party. She is draped over a tuxedoed young man on a couch, her bare legs akimbo, and she fairly exudes sexuality. Allard and Schneeberger call her Temple, after the Faulkner character from *Sanctuary* and *Requiem for a Nun*.

A lengthy discussion centers on a photograph shot at a state mental facility, of a retarded teenage boy. There are two versions of it: a blunt, frontal one in which the child's mental state is plainly evident on his face, and another more active but oblique image in which the boy's forehead is cropped at the top, his gesture echoed by two other figures in the near distance. Schneeberger cut the second version before Allard got back from Mississippi, but he's reinstated it, substituting it for the more direct image.

"Wait a minute," says Allard. "How did we miss this?"

"I think it might be easier to work with," Schneeberger says. "Plus the organization's better."

"It's a whole lot more subtle," says Allard.

Schneeberger flips the lights on, and the two men retire to the lightbox in Schneeberger's office. "You've been working, Jon," Allard says. " This is much better than last time." They spread the slides out.

"I think you might be right about the retardation picture," Allard says. But he is still obviously stewing over the decision, and studies each version with the loupe. "In the original, you go right to that boy's face, and there's no doubt what you're dealing with," he says. "The new one's a nice image, maybe a stronger picture," he concedes, but he seems to be changing his mind. Schneeberger will prevail ultimately, in part because of both men's pragmatic sense of what will pass publication muster.

Schneeberger pushes some of the slides around, changing their sequence. "Damn," he blurts, tapping his finger along a half-dozen slides. "Just a short stroke like that makes it happen."

Left out of the sequence is a classic calendar shot, of silhouetted fishermen on the beach at a reservoir, the sky and water a rich, iridescent purple. It's the sort of picture that would make a more complacent photographer a mint through a stock agency, but it's too safe, too easy to satisfy either Allard or his acerbic picture editor.

"Any chance we can drop that one?" Allard asks.

"Sure," says Schneeberger, tossing the slide to the far corner of his expansive lightbox with a seasoned flick of the wrist. "It shouldn't be in there anyway."

# AT WORK: WORKSHOP

Norfolk, Virginia. The Chrysler Museum is holding a series of weekend workshops and has asked Allard to come for two days to teach the first installment. He has also conducted sessions at the Maine Photographic Workshop, and in Colorado and Oklahoma. How he proceeds depends, like everything else, on his mood at the time, but in Norfolk he's in a particularly inquisitive and positive frame of mind.

The small class that gathers on Saturday morning is an odd amalgam of the tentative, awed and keen: first day at school. The plan is to spend the morning looking at Allard's pictures and receiving his critique of students' portfolios, the afternoon pursuing an assignment, and the next morning critiquing the results. Allard senses the hesitation in the room and starts slowly, trying to put the class at ease with flashes of self-deprecating humor, but he does seem to take up an inordinate amount of space in the small, windowless room. He has two advantages as a teacher, however: his pictures, which provide their own educational dimension, and an aversion to setting himself up as any kind of ideal.

" There are a lot of things about photography I can't articulate," he says. "I can't always tell why something is good or bad. Also: this is only what *I* think. It's not gospel." Allard starts projecting the first tray of work from Peru. Gradually the class begins to ask questions, at first about technical matters, and he gradually warms to the task, stimulated by the chance to talk about what makes pictures work.

"I'm currently experimenting with mixing ambient and flash light," he says, "just feathering it with the strobe at long shutter speeds, so you get a sharp image on a softer one. I usually shave exposures—but everything doesn't *call* to be underexposed.

" These pictures are mostly candid. I wouldn't say I never direct the subject, because that wouldn't be true. There are times when it's one-on-one and you can do it. But I tend to react more than direct."

How does he communicate with people? "There's all kinds of communication you can have with your subject, whether you speak the language or not. It's one thing to expect your subject to be receptive, but *you* have to be receptive to *them*. If you sense something negative, then you back off. You don't have to have a graduate degree in psychology to figure out that somebody doesn't want you to do what you're doing. And if they feel you don't care about them, it's going to show in your pictures. A press credential doesn't mean a thing—it comes down to the way they perceive you. You can't just swoop in, make your hit and leave. But you can't be spooked off, either. You have to project a feeling of innocence: 'I don't mean you any harm.'

"Photographing people requires a willingness to be rejected. Even so, I think the best approach is to be honest and direct. That doesn't mean to show all your cards right away, and give up at the first sign of resistance. You can't afford to do that. There really aren't any formulas for how to approach a human subject."

Someone asks a question about something in the background of a picture. "Is that background?" he replies. "Or is that part of the picture? There's nothing secondary here, and that sounds secondary. If it's extraneous, it shouldn't be there."

"If you remember only one thing about this workshop, I hope it's listening to me harp about cutting away the extraneous—getting rid of what you don't need. What you exclude is as important as what you include. You don't have a lot of room on a 35mm frame and you can't be sloppy. In the street you have no control over anything but your individual ability to select. Simplify. That doesn't mean your pictures can't be complex. But if you strive for simplicity, you're more likely to reach the viewer."

Allard is frank about the shortcomings of his pictures. "Now why the hell didn't I move six inches to my left? If I had, I would've cleared the man with the cornet. And I don't need this here. It's sloppy . . . This picture would have been more successful if I'd used a tripod; it would've been a bit sharper all around."

Allard questions his composition on another image. "Do I need that utility pole?" he asks. "It would've been cleaner without it, but I'm not gonna crop it now. You don't want to photograph with the attitude 'I'll fix it later.' You're responsible for every inch of that space. But composition, I believe, is intuitive. I don't make a picture with the thought, 'Hey, this is a statement I can make about these people.' I was more aware of it as color and form. You may get it in half a roll; you may use five rolls and never get it. What I don't understand is five rolls showing the same damn thing."

The slide show over, Allard critiques the wildly varied portfolios. He continues to bypass technical analysis. One student shows a picture bisected by a yellow pole, and

Allard is no less severe than he was with his own similarly plagued picture. When the student tells him he doesn't care for the post, Allard mimics him. "You don't care for the post? What's it doing in the middle of your picture?" The student admits he may need more of a "human element" in his photography. "What about a human?" Allard shoots back.

A student innocently waves a very red flag by justifying a not-very-interesting picture by saying he had left plenty of space for an art director to overprint type. This arouses the purist in Allard. "No no no," he says. "You'll be raw meat to the first bad designer that comes along. These are *your* pictures."

Perhaps Allard's most telling offering comes in response to a student's blunt judgment of his own picture, and reflects Allard's belief that the only way to make any progress in this medium is to take chances, and fail repeatedly in the attempt. "That was a failure," the student says, trying to preempt Allard. "Yeah, but not an interesting one," Allard answers.

Everybody is in the same fix: lack of direction, lack of intensity. But Allard offers a *caveat*: "If you've got a lack of passion," he warns, "*I'm* not gonna fix it. You've got to push yourself harder. You've got to start looking for pictures nobody else could take. You've got to take the tools you have and probe deeper."

Another picture shows the telltale perspective of a subject shot from afar with a long lens. "What does a telephoto lens do for you that you couldn't do yourself by moving in physically? Robert Capa said if your pictures aren't strong enough, you're not close enough. What would have happened to this picture if instead of staying in your safe and secure spot and cranking the lens, you'd moved in? It's hard to establish rapport from twenty-five feet away. I'm not going to find out something about that person from fifty yards behind a tree."

Later that evening, in the hotel bar, Allard gives some thought to the workshop phenomenon. "I find that a good percentage of the students in my workshops are there because they think I can make it easier for them to photograph people. Most people have a hard time with that. Photographing people is a lot harder than going over to something that's inanimate, that can't glare at you or reject you.

"On the other hand, I'm sure there are a lot of people working in photography who are basically shy, and being behind the camera lets them overcome that shyness. It allows them to have some kind of relationship or contact that they might not have been able to have if they didn't have a camera.

"Of course there are always lots of excuses. One woman told me, 'God, I don't ever

want to photograph again.' As a matter of fact, there are a whole lot of people who should feel that way. But I've never been able to just right out front tell somebody, 'Look, why don't you find something else?' In any case, you shouldn't show work that you feel you have to apologize for, or that you're not totally sure about. In the real world, if you put a mediocre picture out on an editor's light table, there's a chance it'll be used. And if it is, you'll have nobody to blame but yourself.

"I come down hard on simple things—exposure, basic technique—because if you don't have a handle on them, the more important stuff isn't worth discussing. There's no room to screw up, particularly in 35mm, where you've only got a little piece of film. And with transparency film, you can't go into the darkroom to try to save it. You've got to get it in the camera.

"Of course, I had exposure problems when I was starting in color, and I still do. And with color transparency material, exposure is everything—absolutely crucial. This is what I pound into people when they come to these workshops: You can't be sloppy. You'll hate yourself when you lose a picture to carelessness.

"I really do feel that when it comes to the element of color in photography, there's a limit to what you can teach. I think a tremendous amount of it is intuitive. So the best advice I can give is to just throw the reins away and let the color take care of itself. What's really important is to *simplify*. The work of most photographers would be improved immensely if they could do one thing: get rid of the extraneous. Nothing is more discouraging to me than looking at a batch of film and seeing that I've missed the mark. 'Why did I take that?' I ask myself. 'Why didn't I see that *there's* the picture?'

"You can't always work at the same level of intensity," he continues. "But you have to care. You can't do good work if you don't care. I really love what I do. That's not necessarily a strength, but it gives you strength."

FRANCE 1983

FRANCE 1967

# PORTFOLIOS

**W**illiam Albert Allard makes pictures. But in the context of a published article, do they make a picture story? "I was weaned on the classic picture story: a series of images brought together on a certain subject, person, or place that has a beginning, a middle and an end," Allard says. "In a picture story, you're liable to see the same people throughout—Gene Smith's country doctor, or nurse midwife. It's narrative. But the stories I've photographed aren't picture stories. I believe in the discipline of the picture story, but there's almost no outlet anymore. In my work, you rarely see the same person more than once. The stories I do for *National Geographic* are much closer to a photographic essay. I'd define the photo essay in much broader terms. There's more room for impressionism in a photo essay, and this leaves more room for the viewer. A photo essay isn't as literal as a picture story.

"Picture stories are also usually physically different, in that you'll often see large and small pictures mixed together. When I started at *Geographic* in 1964, they did this a lot. Size was used as a way of indicating the importance of the picture. Pictures that were run small were called point pictures. A point picture isn't a great picture, but it gives you a little information. I used to dread hearing something referred to as a point picture, because I knew there was a good chance they'd use it. And if they ran a point picture, it would eat up some of the space that could be devoted to a better picture.

"The *Geographic* doesn't use this approach much anymore; the likelihood of insignificant pictures being used is much less. Now they let the photographer's vision drive the story more than they did then. I don't think you can make a photo essay of big pictures and little pictures. I have never gone out with the idea of making a little picture."

# BASQUES

I went to the Basque country of Spain and France in the fall of 1967. It was one of those places where my work, for whatever reason, went especially well. I felt very much in tune with the place. It was just one of those experiences that clicked inside— I thought, "This is good."

It was the first time I'd ever gone to France. I found the Basque people interesting. There was a simplicity that existed then; the people used animals to work the land, and the whole culture was less dependent on machines.

I was still very much in the fingerpainting stage of photography. I felt more freedom, was less conscious of the rules, than later on. Even though I didn't speak the language— sometimes I used an interpreter—I drifted around a lot by myself. I'd just drive off into the mountains and go hunting. One thing that's nice about the Basque country as a place to work is that it's a fairly small region. You can cover a lot of ground in a relatively short period of time.

I think the story as published looked pretty decent, but this was a situation where I don't think I realized what I had until later. There are good pictures that I don't remember pushing to have published. I think now, "Why didn't I try to get more attention paid to these and have them included?"

You can see that the three men standing in the doorway are workmen (p. 74). It was a rainy day, and I was sitting in my car across the street. One man came over and we had a conversation through the young woman who was with me. I made a few pictures of him, and I could see the other two kind of gathering in the background. Finally I went across the street to take some pictures. I didn't direct them at all. It's almost always my preference to react rather than direct. I just kind of worked around the edges, and slowly moved in.

I was driving down the road and came to a screeching halt when I saw the man

shoeing the cow (p. 76). At first glance it looks as if the animal is suspended in midair. I recall photographing the animal in a number of ways; I took some pictures from directly in front of it, which made it look a little surreal. I didn't work more than fifteen minutes.

I've always liked the picture of the kids playing in the square, the juxtaposition (p. 75). It's as though the middle kid is perched on the back of the foreground kid.

The picture of the little girl in the cemetery (p. 78) didn't run in the *Geographic* story, but the same girl did appear in the photograph of the children running down the road, which was the last picture in the published story. I found her in a small village in the French part of the Basque country, just a little way from St.-Jean-Pied-de-Port. I loved to make the drive up there. Occasionally I'd find kids playing in the cemetery next to a seventeenth-century church. I don't think I photograph children any more than other photographers do; it's just that children are very often an important part of the environment, and if they're preschool kids or school's out, they're around. They're wonderful subjects, and not really affected by your presence—although she's watching me every bit as much as I'm watching her. I love the dress, all the little flowers that are a kind of repetition of what's going on here, and the little creases.

The portrait of three men's faces (p. 68)—definitely Basque faces—was taken during a festival. The Basques are famous for their poets, really troubadours, because their poems are sung. They make up the verses as they go along. These men are listening to the poets.

The road (p. 79) is below the church where the little girl was playing in the cemetery. It was late afternoon. I was looking at the vineyard when I heard a woman's voice, I think it was their mother, calling them home. When I heard them go by me, I turned. The sun had gone down, but it was reflected and softly diffused by the clouds, and the light draws you into the center of the picture. If I were to go back to the original story and say "Let's cut it down to rock bottom," there are two pictures that would make it through—this one and the three men listening to a poet. They're pictures that will always, for me, bring up the same feeling. If I can make another picture half as good as this one five years from now, I'll be happy.

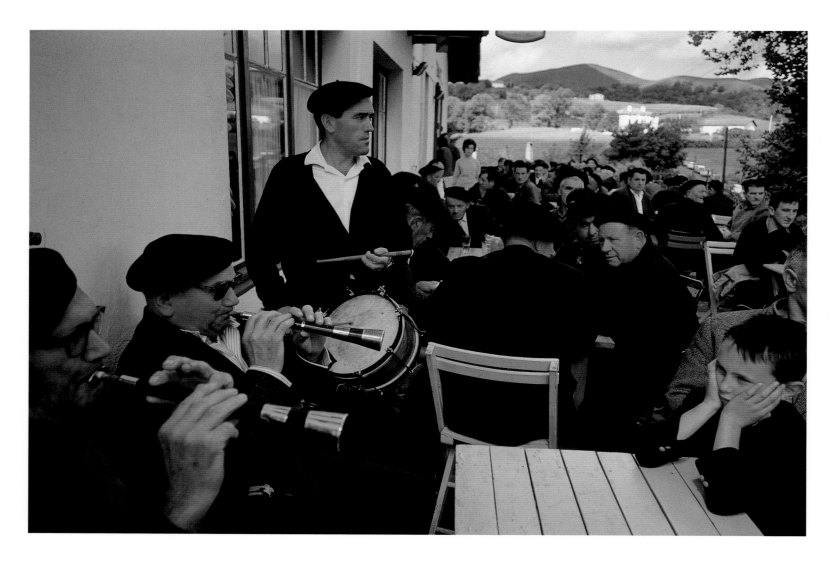

FRANCE 1967

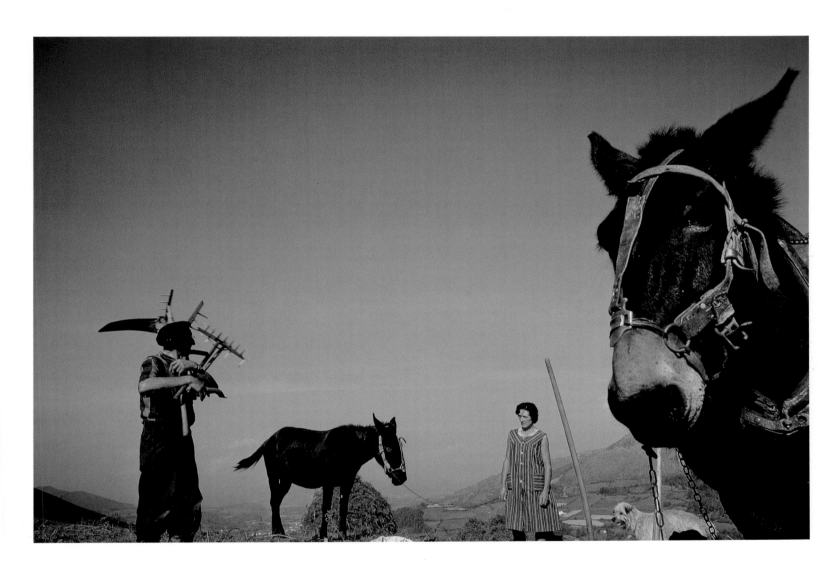

FRANCE 1967

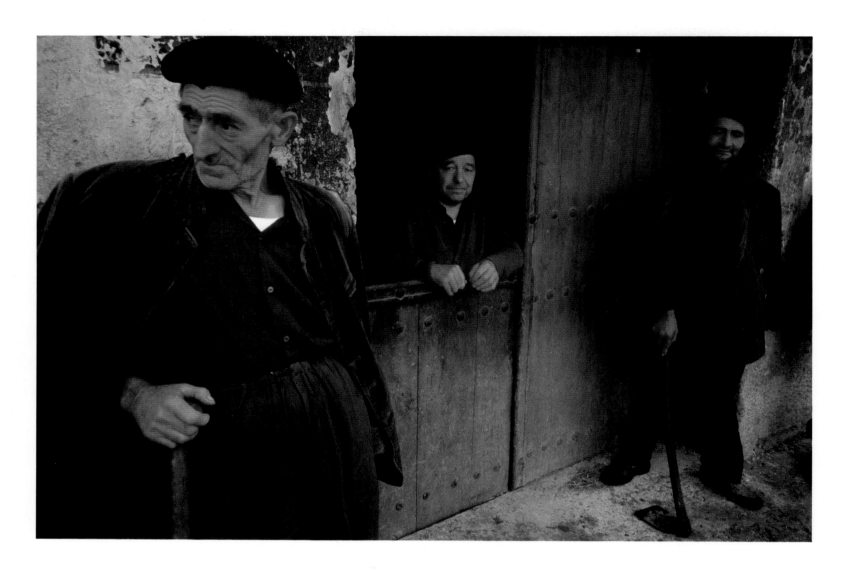

SPAIN 1967

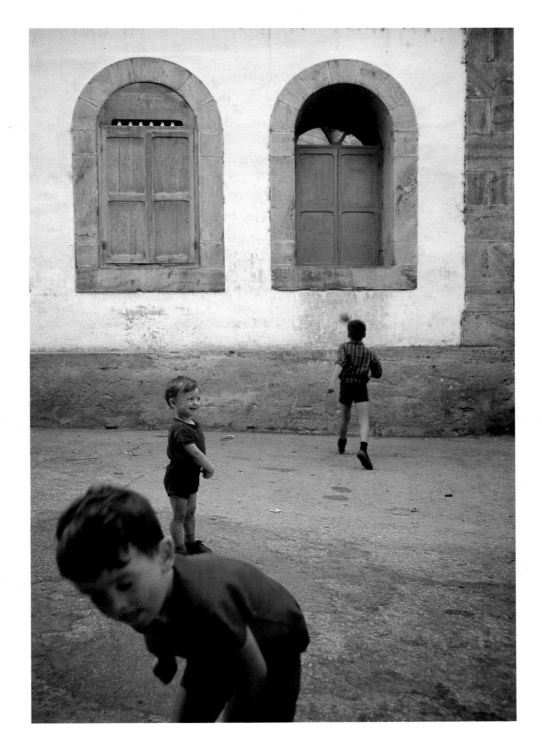

FRANCE 1967

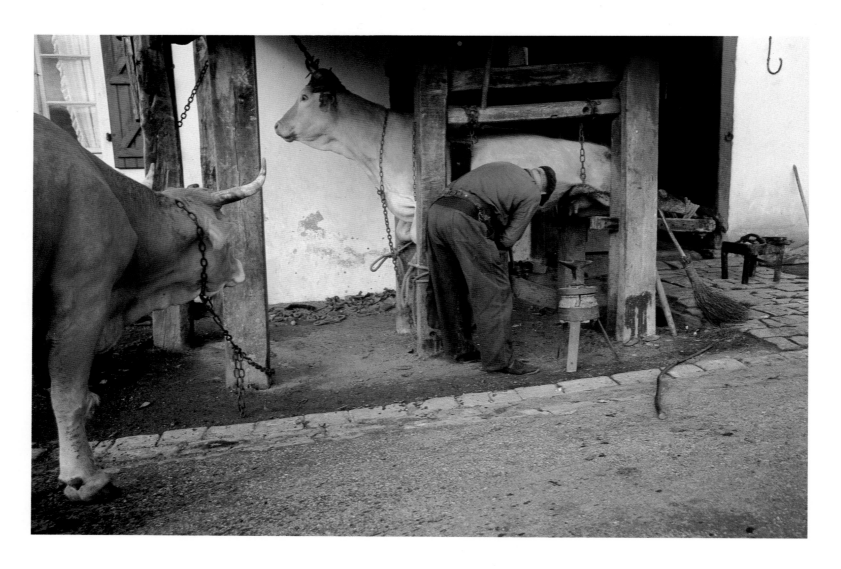

FRANCE 1967

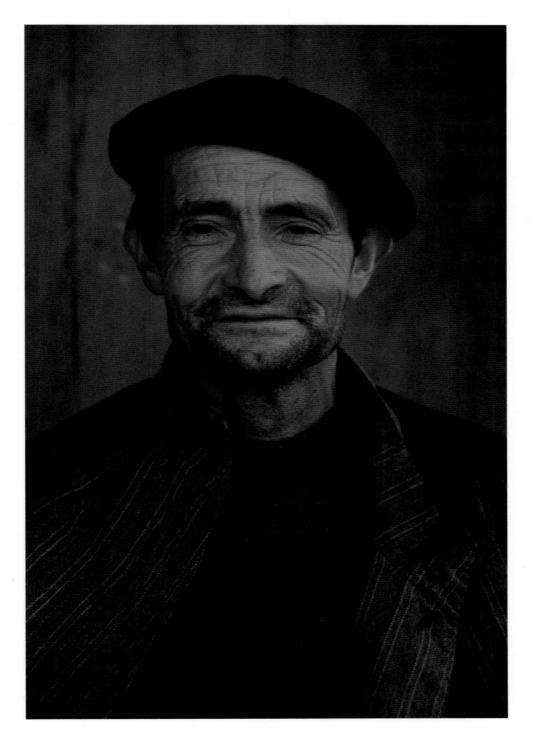

SPAIN 1967

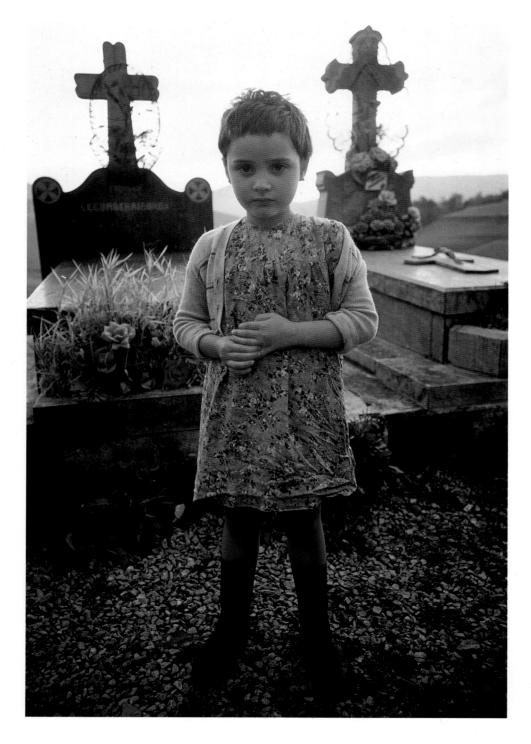

FRANCE 1967

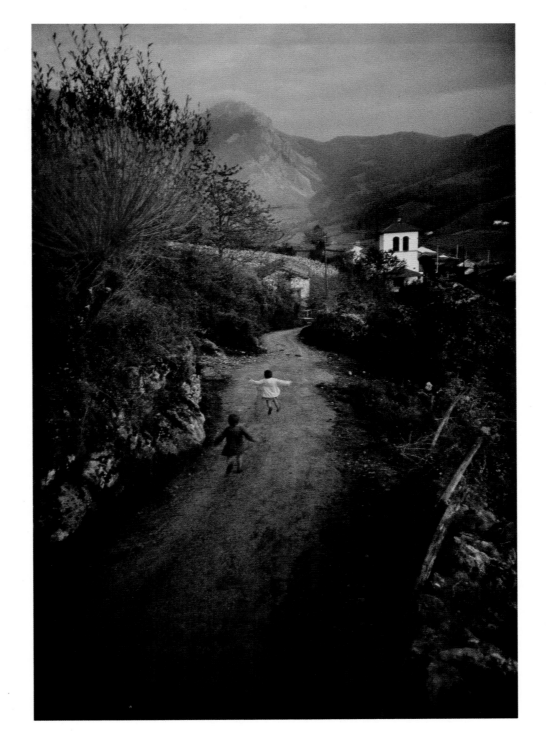

FRANCE 1967

# THE WEST

I photographed a number of stories for *National Geographic* in the West, beginning with Yellowstone in the winter of 1966, and ending with an unpublished story on the mountain men in 1979. I've been out there a number of times since then, on shorter assignments for *Life, Stern, Geo,* and Polaroid.

In the fall of 1979, I drove to a Nevada cow camp where I planned to shoot some Time-Zero instant film for Polaroid. I got there just at dark, and when the hands came in I introduced myself and broke out a bottle of George Dickel. Most of the guys were quite young. The boss was only twenty-one, a buckaroo named Hank. They really do call themselves buckaroos—a bastardizing of the Spanish word *vaquero.* I stayed with this outfit for a couple of weeks, sleeping in my van, working cattle with them.

The buckaroo in the corral is wrangling his horses— gathering them together for the night (p. 88). These are his working horses; each hand has maybe five or six which are his to use. I was sitting on the corral rail when I made that picture. Sometimes they just drive a circle of picket stakes into the ground and string a single strand of rope between them as a corral. The horses will stay inside the rope.

The picture of the three cowboys roping the cow was taken almost eight years earlier, on the high desert in Nevada (p. 84). It's made with a wide-angle lens, which I think enhances the sense of open space. These cowboys were part of an outfit that I spent a lot of time with, riding on pretty good-sized cattle drives. They've roped a cow and put her down to doctor her. The mounted cowboy on the right is Claude Dallas. Ten years later he shot and killed a game warden and his assistant out in Idaho, and became one of the FBI's most wanted men.

The young man with the bread is T.J. Symonds (p. 89). He was about seventeen at the time, originally from South Dakota. He'd been a failure in high school, so his father sent him to Nevada to work on a ranch. On the morning I made this picture, the other

hands were just leaving to gather cattle, and T.J. had stayed behind because the day before he'd been out with the crew and gotten dizzy and nearly fallen off his horse. He'd passed out and they'd rushed him by pickup truck into the nearest town, which was about sixty-five miles away. It turned out he'd just had some kind of heart flutter, but when he came-to in the hospital and looked up and saw all these people in white, he thought he was dead. Afterwards he and the other cowboys went to the local saddle shop and bought new hats and new shirts. They ended up in a cathouse.

I'm sure that picture is made with a 50mm lens. I try to make myself use the 50mm more often than I might've a couple of years ago. I think the 50 is an extremely good discipline lens; it requires you to see in a more refined way, not just tighter.

I get asked a lot, whether I used a filter for the picture of Stan Kendall in the bar, because there's so much red in it (p. 90). I didn't, and I almost never use filters. The reason there's so much red is that there's so much red in the environment. The bar is red, the counters are red, his shirt is red, the barstool tops are red, and the light's pumping it all up. For that picture to be successful, obviously I had to get the exposure right. I exposed for the cowboy knowing the sunlit area would be blown out. Actually, if there were more detail there I think it would be distracting. But this is a tough one to reproduce—a printer's nightmare.

I was in Oklahoma City covering a particular rodeo cowboy at the big rodeo finals, and took some pictures in the dressing room of the rodeo-queen finalists (p. 86). The women are putting vaseline on their teeth and gums, which keeps their mouths from drying out and makes it easier to smile. It also makes their teeth glisten. The key to that picture is the almost claw-like hand that's coming into the jar of vaseline. Not a typical romantic Old West picture.

I did a story for *Life* magazine on the man on the horse (p. 93). He was a range detective. Earlier in the year I was reading an article in an airline magazine on cattle rustling, and though I felt I'd just about played out the West and cowboys and was moving in other directions, it was a year when I was doing very little work. This was one of the only two editorial assignments I had that year. The rustling article mentioned a man named Ed Cantrell, and that rang a bell. I realized that this was a man who used to be the top law-enforcement official in Rock Springs, Wyoming.

In the seventies, when the oil business was booming, the town was rife with drugs, prostitution and gambling, and Cantrell was hired to keep a thumb on it all. He had a young undercover agent working for him who was allegedly working both sides of the

fence. One evening Cantrell and two other lawmen pulled up outside a bar where the young agent was drinking, and they called him out. While he was in Cantrell's car, Cantrell drew his gun and shot the guy between the eyes.

Although Cantrell claimed the agent was about to draw on him, he was indicted for murder, but a lot of ranchers got together and hired Gerry Spence, a prominent attorney who got him off on self-defense. But his law career was over, so he ended up working for cattle associations as a range detective, to combat rustling. I wrote a query letter to John Loengard, who was still picture editor at *Life,* suggesting that they do a story on cattle rustling with a focus on Cantrell. I got an immediate response. In a professional sense, the importance of this picture is that it resulted from a project that I generated by picking up on a subject that looked promising, and sitting down and writing a query.

The picture of Henry Gray was made in 1970 in a small Arizona town near the Ajo Desert (p. 83). I was traveling by motorcycle, photographing the US/Mexican border for *National Geographic.* I remember he had two photographs on the wall in his kitchen, one of a young Richard Nixon, the other a hand-tinted picture of Jack Dempsey in his fighting stance. Henry was a tough old man who had pulled most of his own teeth. He'd ranched his land for two or three decades, and the government was trying to get him off it so they could turn it into a state park. That's a forty-eight-star flag. We were just talking as I made pictures, which is the way I work when I'm alone.

The picture of the dead buffalo (p. 87) was taken for a *Geo* story, during an annual buffalo roundup in South Dakota. Anytime you round up wild animals, some of them get injured, and you have to put them down. This buffalo broke its neck, and they've put it up on a boom on the back of a truck. The carcass will be butchered right away, and the meat possibly given to an Indian reservation. The picture gets part of its quality from the combination of dusk and a little bit of light from a small, hotshoe-mounted strobe.

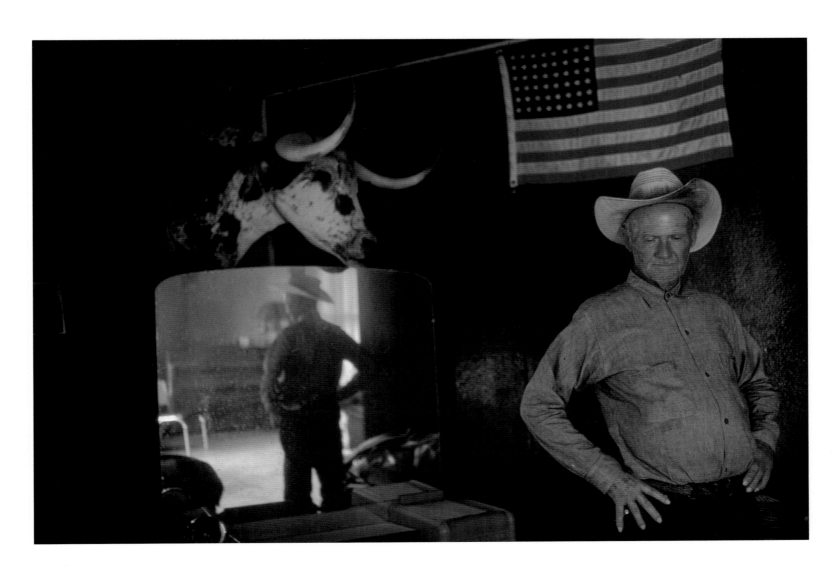

HENRY GRAY, ARIZONA 1970

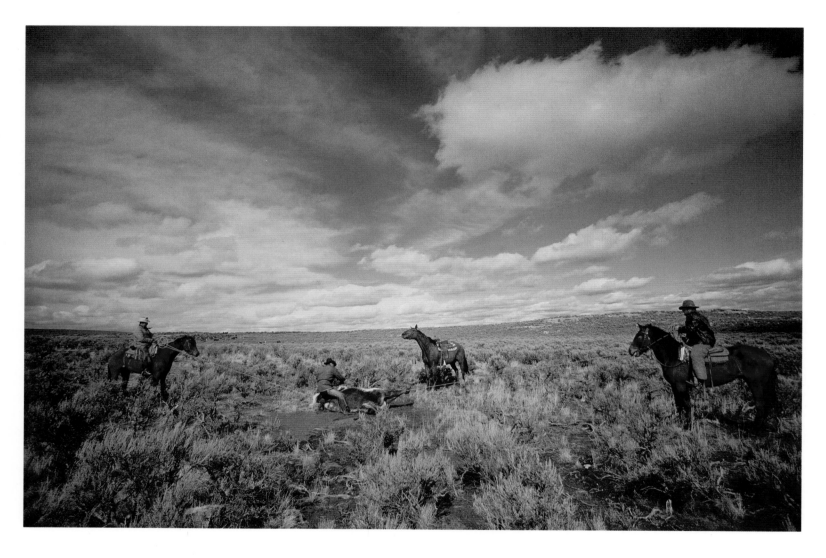

NEVADA 1971

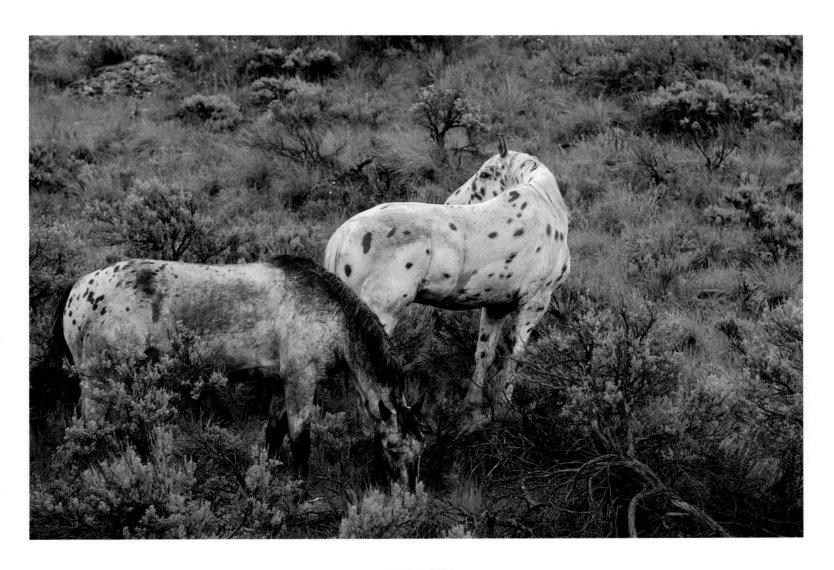

IDAHO 1975

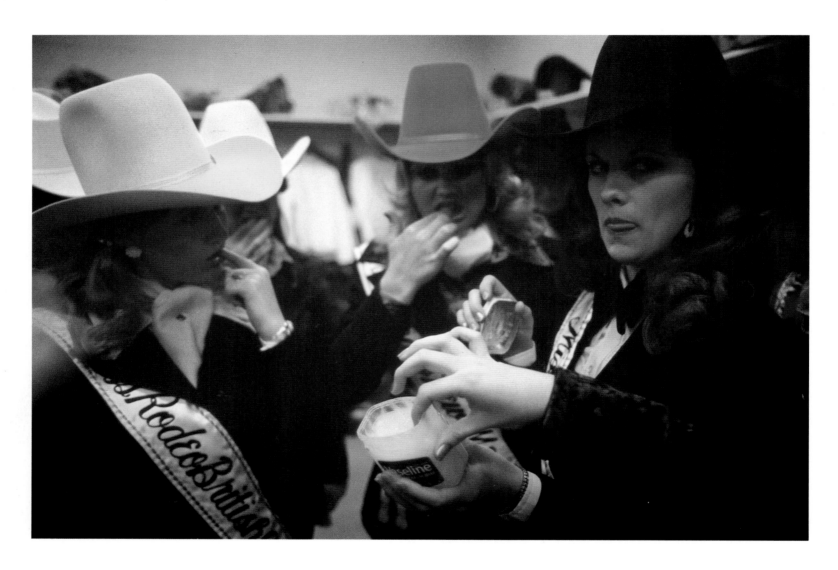

OKLAHOMA 1977

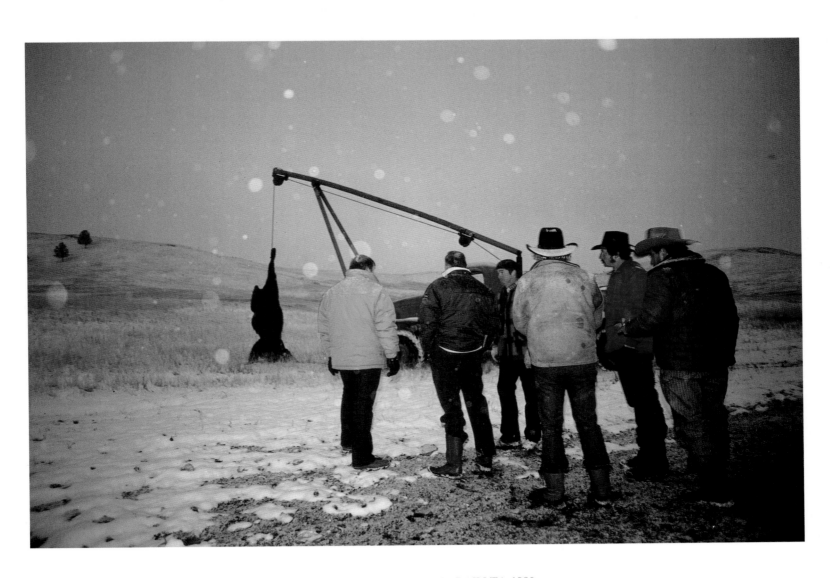

DEAD BUFFALO, SOUTH DAKOTA 1980

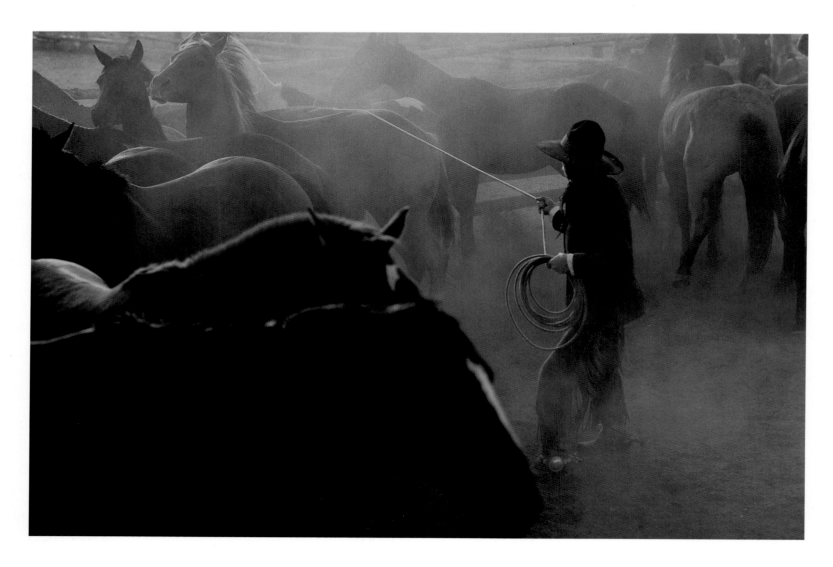

NEVADA 1979

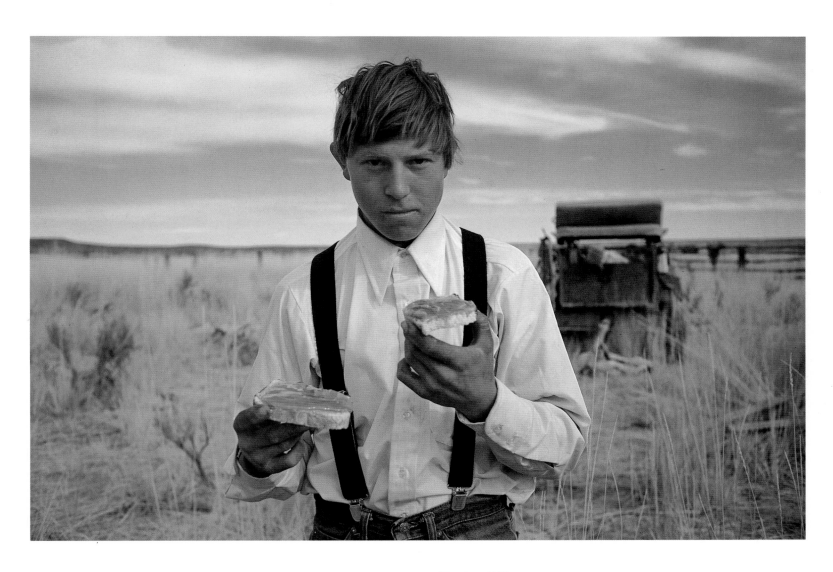

T. J. SYMONDS, NEVADA 1979

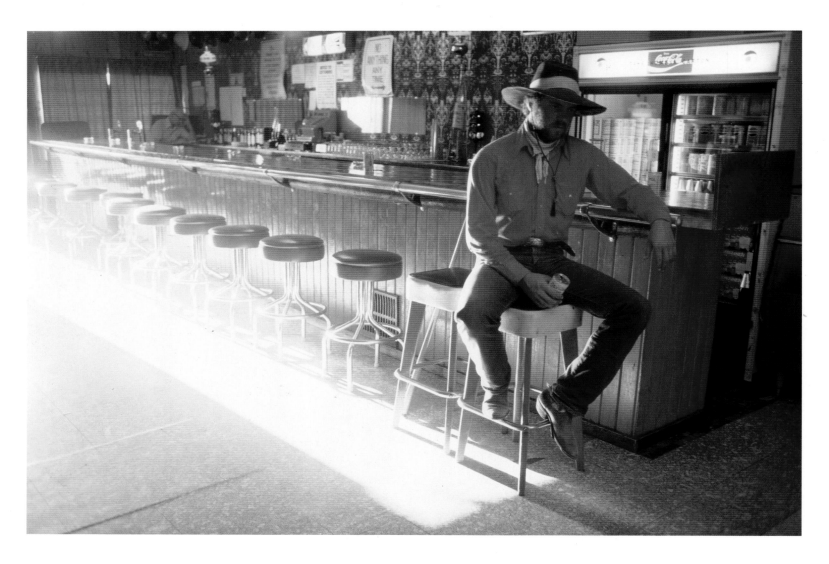

STAN KENDALL, NEVADA 1979

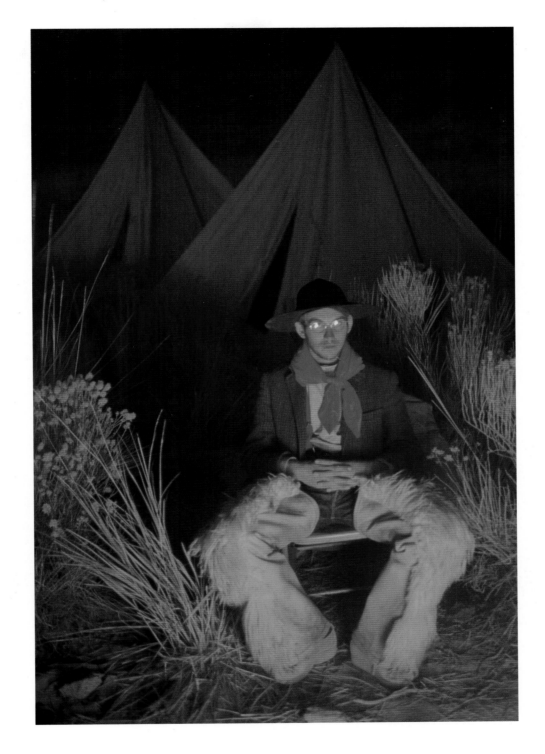

RICKY MORRIS, NEVADA 1979

MONTANA 1983

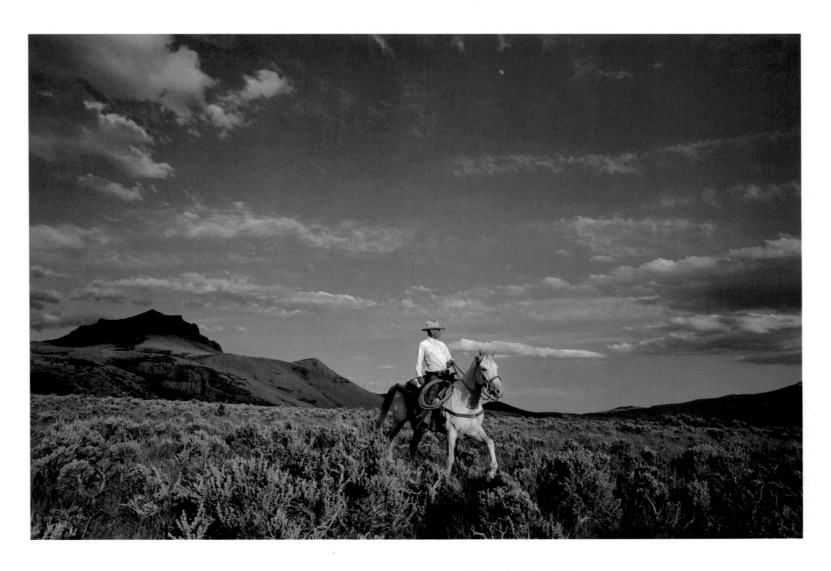

ED CANTRELL, RANGE DETECTIVE, WYOMING 1983

# OAXACA, MEXICO

An assignment from Polaroid got me to Oaxaca. I was asked to shoot some of the new Time-Zero film for the SX–70 instant camera. The beauty of it was that they didn't want the pictures for commercial use. The idea was simply to have a one-man exhibit at Polaroid's Clarence Kennedy Gallery, if the work proved to be good enough. The assignment demonstrated something that I hadn't really thought about—that the best way to work is with no strings attached, if at all possible. Of course in terms of shooting, my first responsibility was to use the Time-Zero film. But I did a lot of 35mm work too. I was fortunate to get another Polaroid assignment in Oaxaca in 1985.

Every day I would make a swing through one particular market area in Oaxaca. I'd set up a tripod and do Polaroids, and wait for people to come by. The picture of the young woman carrying a baby is a pretty consciously constructed picture (p. 105). I waited for people passing by to fill the space in that patched wall, shooting with a mix of strobe and ambient light.

The photograph of the young couple in the doorway came more from wandering the streets (p. 96). What intrigues me about this picture is how that one shadow stretches across the street and up the wall, becoming a third figure in the doorway. The boy is imposing himself over the doorway, and over the girl in it. It's a familiar sort of image if you know anything about Latin countries and machismo.

The table full of meringue-like confections is a street-vendor's stand (p. 100). I like the way it lines up, sort of pointing to the children standing in the doorway in the upper right-hand corner. Somebody must have told them to stay away from that table. It's strange to see children so disinterested in candy.

The interior without any people in it is one of the many small eating places in the main market (p. 98). The flowers are plastic. It's a more studied picture than usual for me. I was interested in the pure physical elements of the place: the checkered table-cloth, the flowers, the repeating of the red in back of the soft-drink signs.

I noticed the seated young girl while I was at a lunch counter in an area adjoining the market, watching people go by (p. 101). The steps lead down to the street. The girl had a little stand nearby, and I guess business was slow, so she sat down for a break. I used a little tabletop tripod to photograph her, because I needed an especially slow shutter speed.

The teenage girl with the braids is a very straightforward image (p. 99). In fact, I've often edited it out of this group of pictures, but I've always put it back in. There's definitely a direct relationship between the girl and the photographer, a one-on-one thing. She's a child-woman.

The two children are waiting with their parents for a bus (p. 97). They're coming from the market, where they bought the sheep. The sheep will be put on top of the bus. The little girl was almost defensive; you look at her face and her stance, and you're not going to screw around with her. That great headdress gives her even more presence. I love the tension of the rope, which seems to be pulling on the sheep. It reinforces the whole diagonal aspect of the picture.

I made two or three pictures of the women with their pigs, like dogs on leashes (p. 104). They were also waiting for a bus. The woman eating the ice cream seems nonchalant, off in her own world. The other seems concerned about something. As viewers we're immediately drawn to the pigs, but it takes us a beat or two to realize they're pigs. The pigs are sort of doing the two women's socializing for them.

At night I'd drive into Oaxaca to eat dinner, and I would always go by the same church. I could see inside when the front doors were open—a big gold interior. It looked beautiful, and I thought, 'I've got to stop there some night.' The night I decided to stop there, lo and behold people start showing up for a wedding. Afterwards, when the wedding photographer was taking the couple's picture at the front door, there was hardly any ambient light, so I waited and tried to use the light from his flash to make my picture (p. 102). I had to guess when he was going to shoot. The foreground came out blue because I was using tungsten film, which was balanced for the artificially lighted interior of the church. It creates a sort of surreal effect. The shutter speed was a quarter or a half a second.

While I was working, an attractive Mexican woman invited me—I don't speak much Spanish, but I knew she was inviting me—to a reception. Somehow she explained where it was, and I went. That's where I photographed the waiter with the great electric heart on the wall (p. 103). I could have told the woman, "Gee, I'd love to, thanks, I'll see you there," and never showed up. In a way, that would have been a lot easier than going to the reception. But then I wouldn't have gotten this picture.

OAXACA, MEXICO 1980

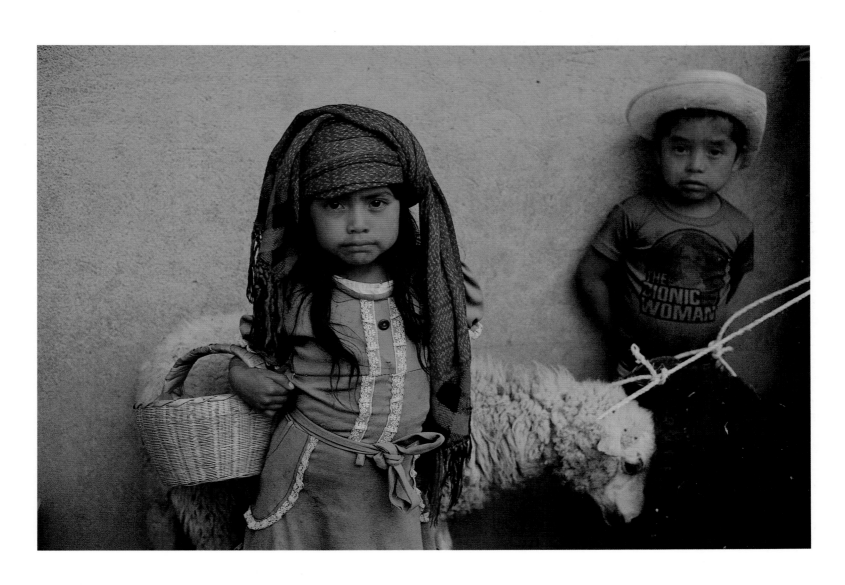

OAXACA, MEXICO 1980

OAXACA, MEXICO 1980

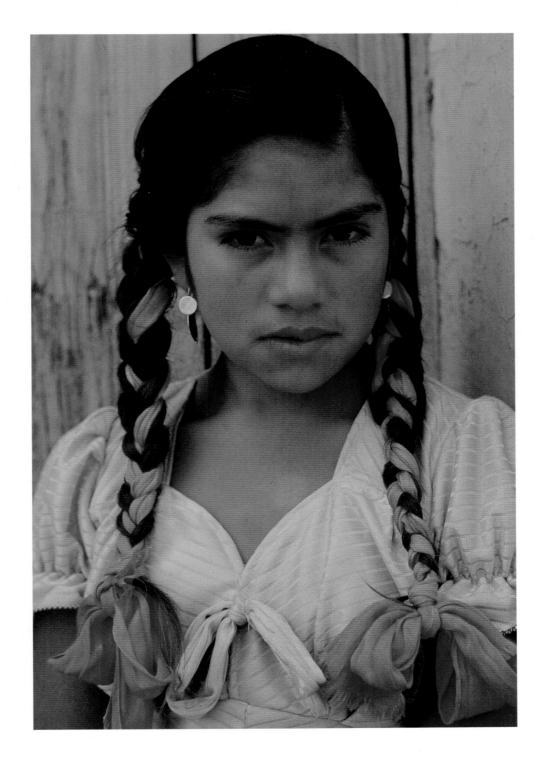

OAXACA, MEXICO 1980

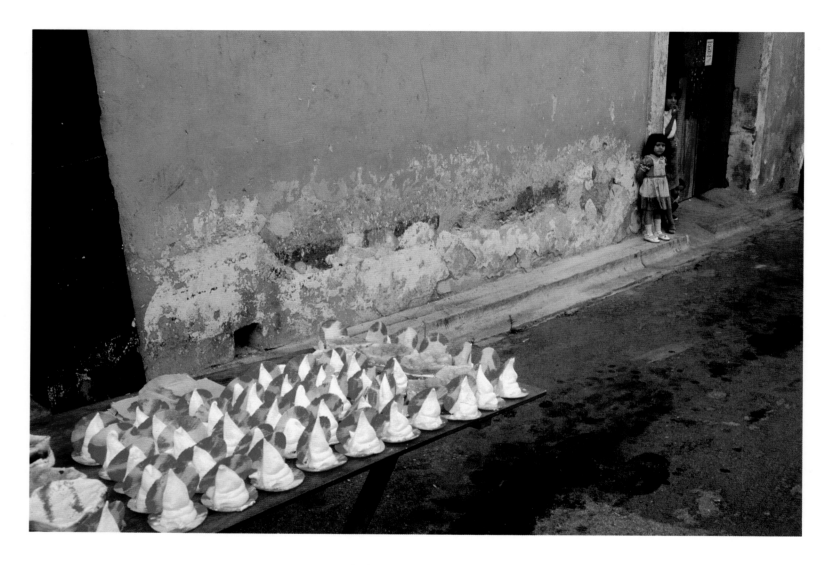

OAXACA, MEXICO 1985

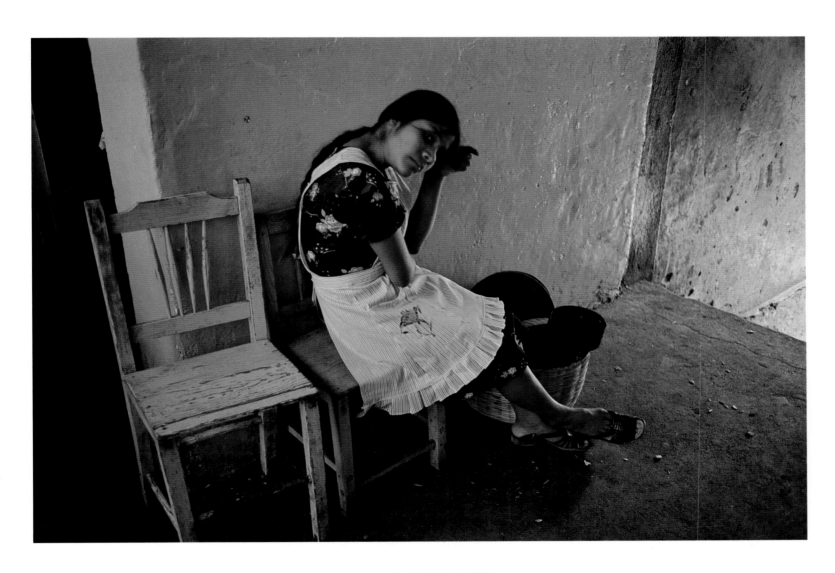

OAXACA, MEXICO 1980

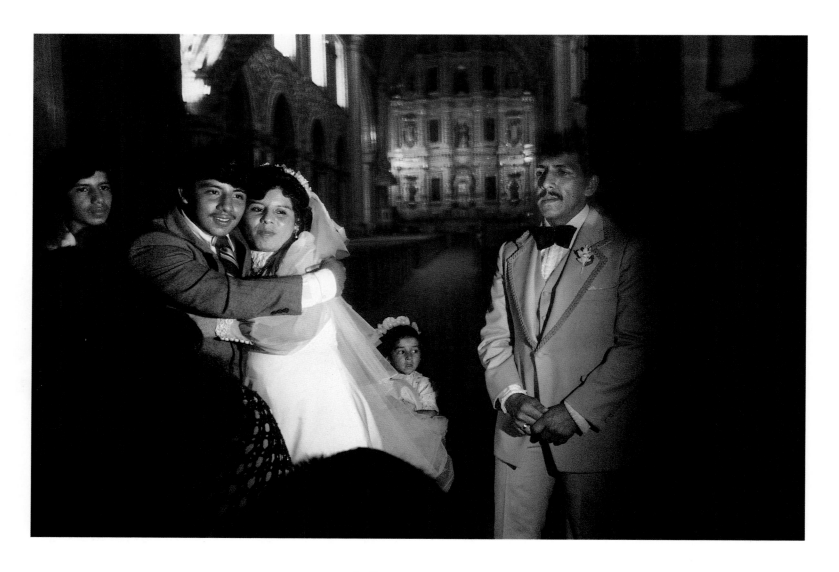

OAXACA, MEXICO 1980

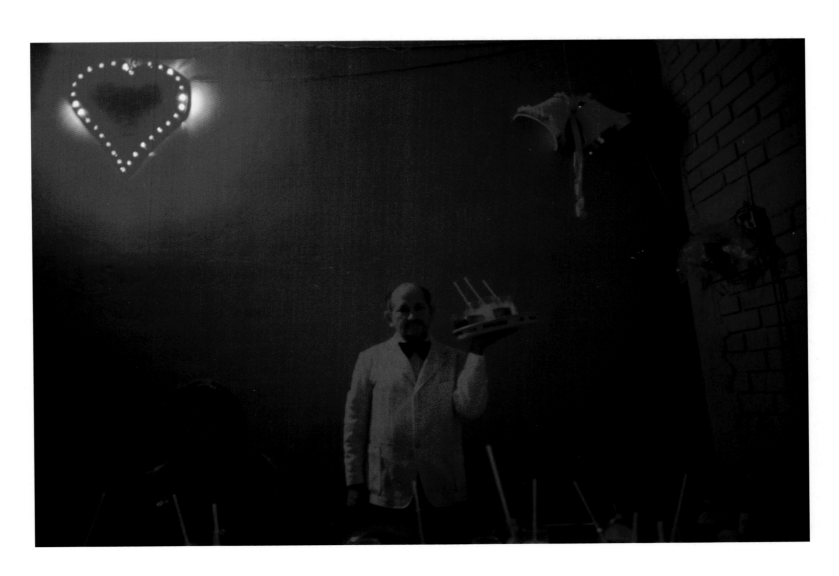

OAXACA, MEXICO 1980

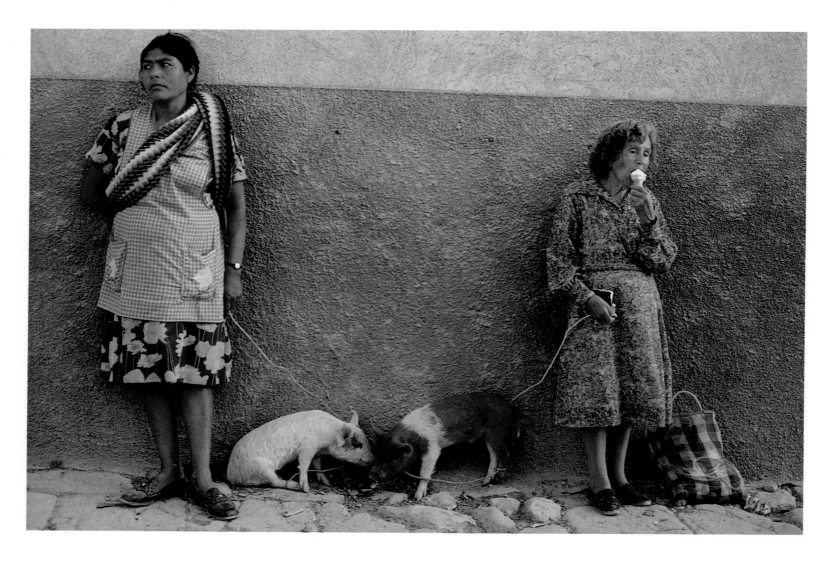

OAXACA, MEXICO 1980

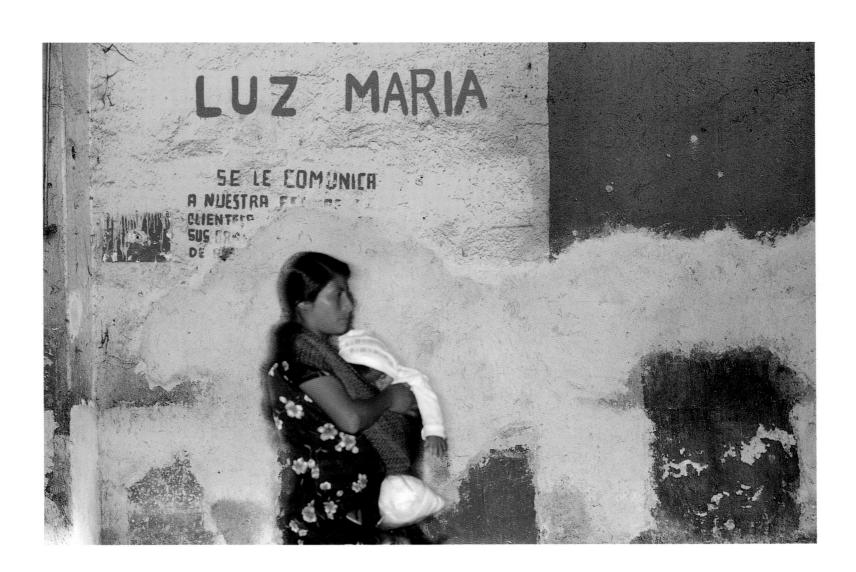

OAXACA, MEXICO 1980

# PERU

Peru is a high-adrenaline country. I found it awesome. That country has so many ways of reminding you that you're alive—and your life may end at any moment. I went there twice in 1981 for *National Geographic*, two months in the spring and three months in the summer and early fall. I try to divide a big assignment into two parts, so I can come back in the middle and appraise what I've done. I've returned to Peru several times since 1981, but it's a much more difficult place to work now than it was then. I don't think I've ever worked as intensely on an assignment, in the sense of working all my conscious hours.

I shot a lot of film in Peru, even by *Geographic* standards. But I'm a working photographer. It's what I do, and my percentage of successful pictures on this assignment was very high. So was the number of interesting failures.

Photographing a market is part of being in that part of the world. I was in the market in Huaraz when I saw the woman bending over the salted fish (p. 111). Because of its perspective, it takes you a minute to realize you're looking at stacks and stacks of fish. It's a more abstract picture than I would have made before. I think I used a 50mm lens. I worked very quickly, shooting four or five frames, slight variations of one another. I wasn't just grabbing at straws. This was the most successful. I like the softness of the white hat. If she'd been wearing a black or brown derby it would have been a whole different picture.

The man walking out of the shadow is a picture I wouldn't have made twenty years ago (p. 112). It breaks all the rules. The space is divided right down the middle. I'd taken some pictures under this archway before—it's in a village called Chincheros, near Cuzco—but I thought, 'I can do better.' I squatted against the wall and watched the shadows change, and waited for the extra element, which was the man. I exposed for the highlights, figuring that the shadows would go almost black.

The three girls looking through the tent were in a mountain village that was hit by an earthquake during Easter week (p.117). Six people had been killed. The Peruvian government sent in a helicopter with supplies and a medical team, and I hitched a ride on it. The medical team set up a tent. It was a small village; the girls would have known anyone who was in the tent. I think the best pictures are often on the edges of any situation, like this one was. I don't find photographing the situation nearly as interesting as photographing its edges.

I remember I shaved the exposure on the picture of the man holding the horse (p.110). I probably cut back by a half-stop or so. It makes the dark shape of the horse stand out more. It also deepens the shadow of the man's hatbrim.

The writer and I were driving near Puno when we came around a corner and saw the young shepherd boy standing by the side of the road (p. 120). A speeding taxi had just destroyed half his family's flock of sheep. This picture says a great deal about the harshness and difficulty of life in the *altiplano* of Peru. When the *Geographic* published it in 1982, reader response was amazing. Letters and unsolicited contributions poured in, to the total of nearly $7000. People from CARE tracked the boy down—he lived in a tiny village near Lake Titicaca—showed him his picture in the magazine, and presented him with five white ewes and a black-and-white lamb. There was enough money left over to pay for new schoolrooms and supplies, a soccer field, and a motorized pump to irrigate the school's garden, as well as a scholarship for the boy. I'm very proud of this picture. It really changed something, made a difference.

The three bullfighters were in Lima (p. 109). They were preparing for the grand entry of the bullfighters at the Plaza de Toros. I was intrigued by the light and how it fell on that salmon-colored wall. But the key is this man looking at a frayed thread on the other man's cape. Structure—all of that space is working, although the right third was cropped in publication. I didn't include that wall, and the slot in it, because I thought it would be easy to crop off later. I try to compose tightly, to select.

The man drinking the glass of water is called a *rejoneador*—he fights bulls from horseback (p. 118). I was behind the barricade when he came over to gulp down a glass of water. The crux of the picture is the sweat on his brow and the wonderful veins on his hand. The hard light really emphasizes them.

The slaughterhouse pictures were made in an older building, with light coming in from an open area (pp. 113–116). The light was workable enough to let me experiment with mixing ambient and strobe light, using a small hotshoe-mounted flash. My shutter

speeds were quite slow, which is why the hog on page 114 is rendered as a ghostly blur. In that picture, I just took an overall reading though the camera, cut it in half, and underpowered the flash, with the idea that the combination of the ambient and strobe light would give me what I needed.

Why was I attracted to the slaughterhouses? I *should* be able to tell you that, but I'm not sure I fully understand my motives. I was curious, but I didn't go because I wanted to see a lot of blood. I asked myself from the beginning, "Can I take this beyond the immediate impact of the blood?" I think there's often a kind of beauty to be found in seemingly horrific situations.

I also think the slaughterhouse is reflective of a certain harshness, a toughness, to Peruvian life. The slaughtering isn't done in the neat, clinical way we do it in this country. Watching it is a little like witnessing a murder. Cattle are brought in on a lead rope and just held by one person, and another man comes in with a little dagger, the kind they use at bullfights to sever the spinal column. The cow is killed with a knife to the back of the neck, and it usually goes down as if hit by a cannon. But the hogs are simply stabbed in the heart and left to flounder around until the life drains out of them in great gushes of blood, and they're squealing all the time.

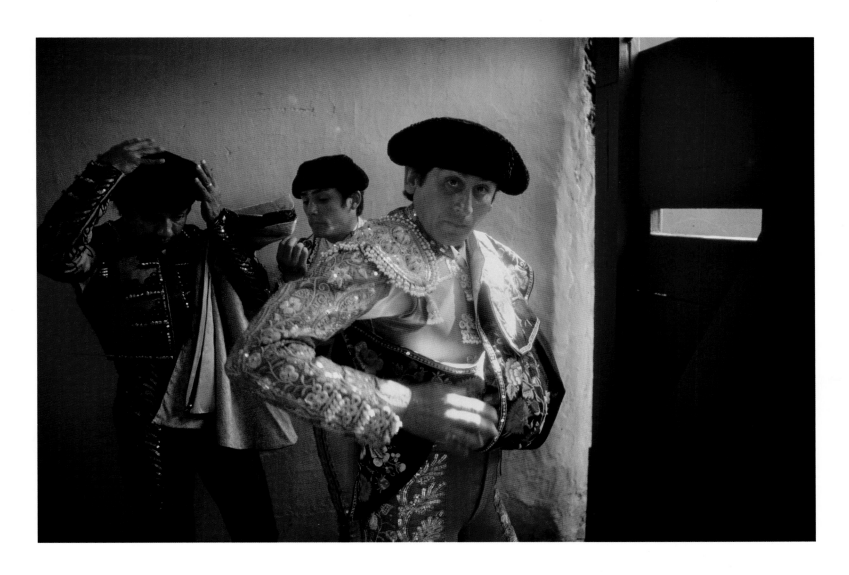

PERU 1981

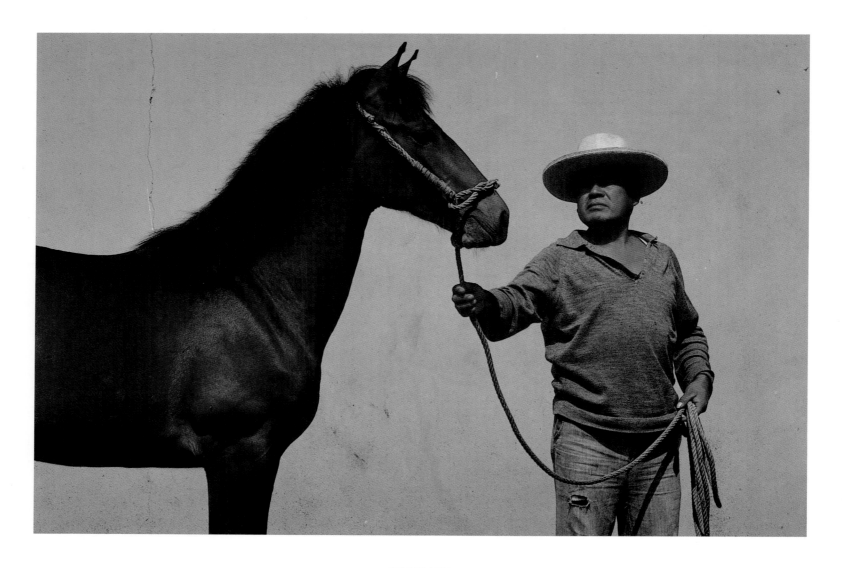

PERU 1981

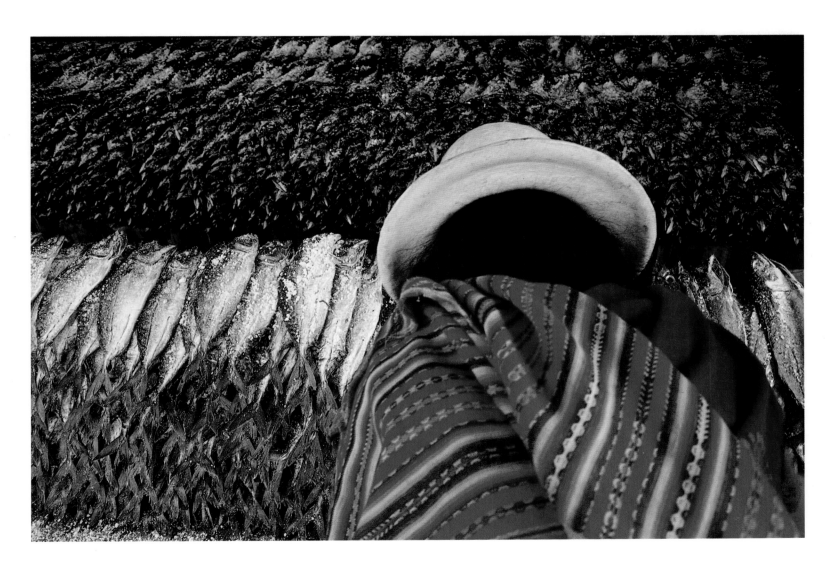

PERU 1981

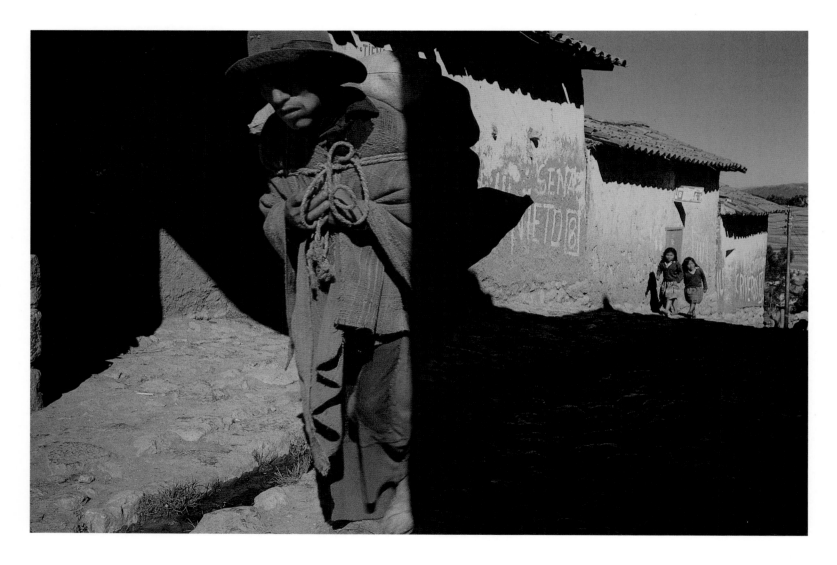

PERU 1985

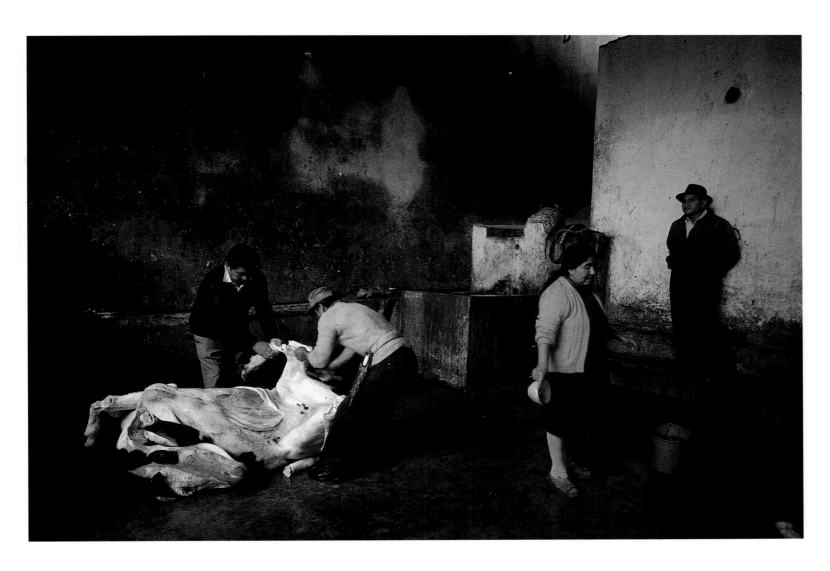

SLAUGHTERHOUSE, PERU 1981

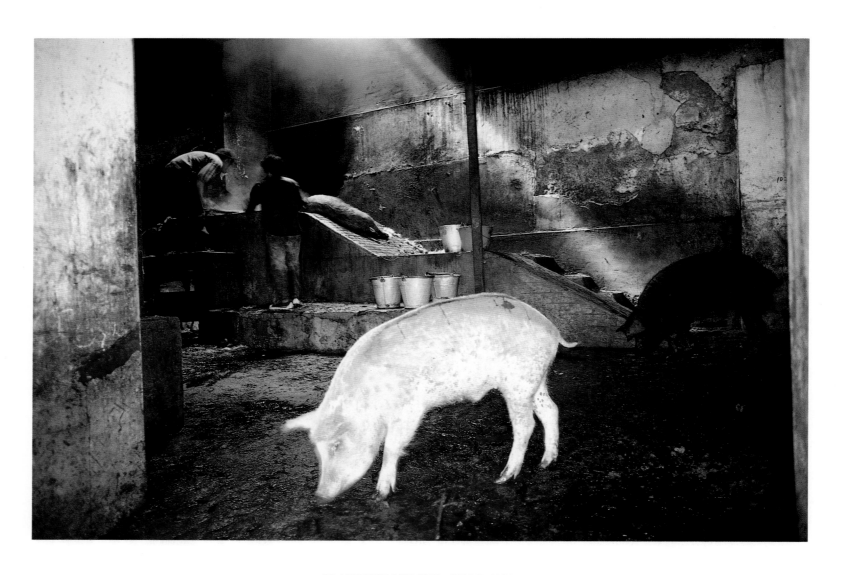

SLAUGHTERHOUSE, PERU 1981

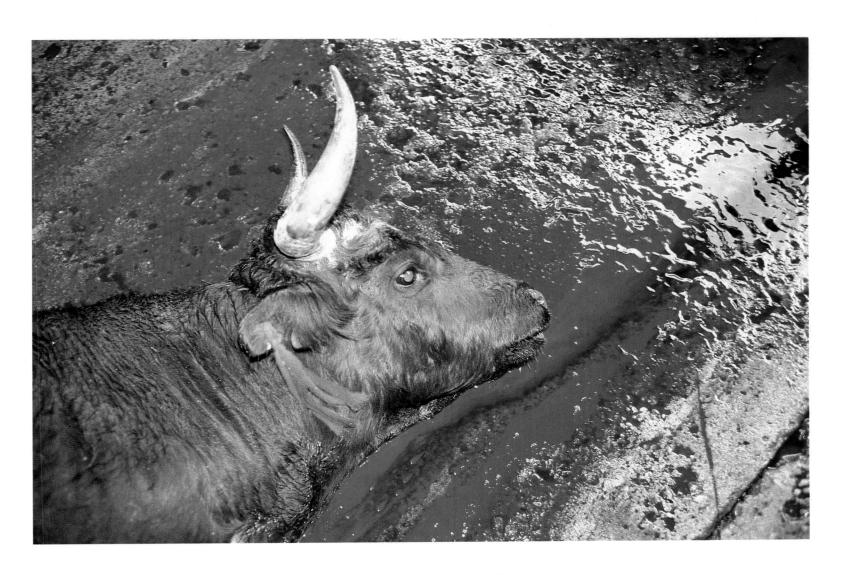

SLAUGHTERHOUSE, PERU 1981

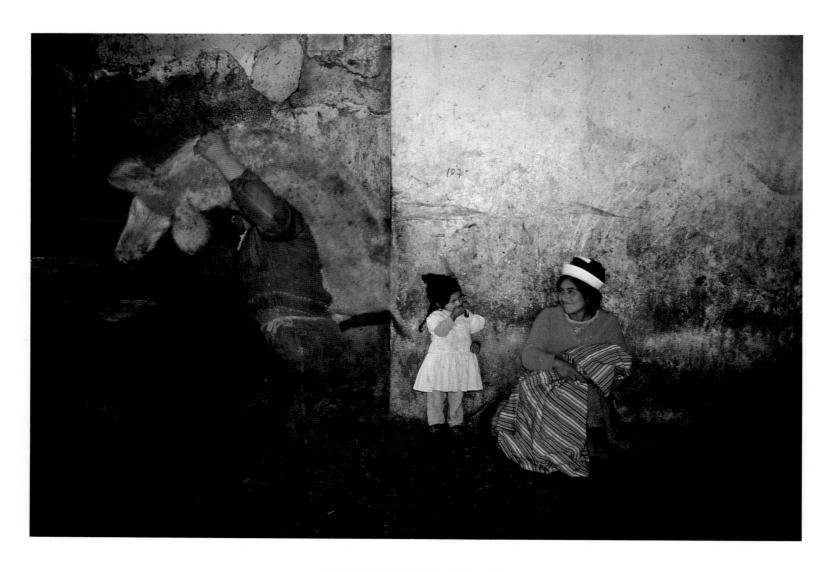

SLAUGHTERHOUSE, PERU 1981

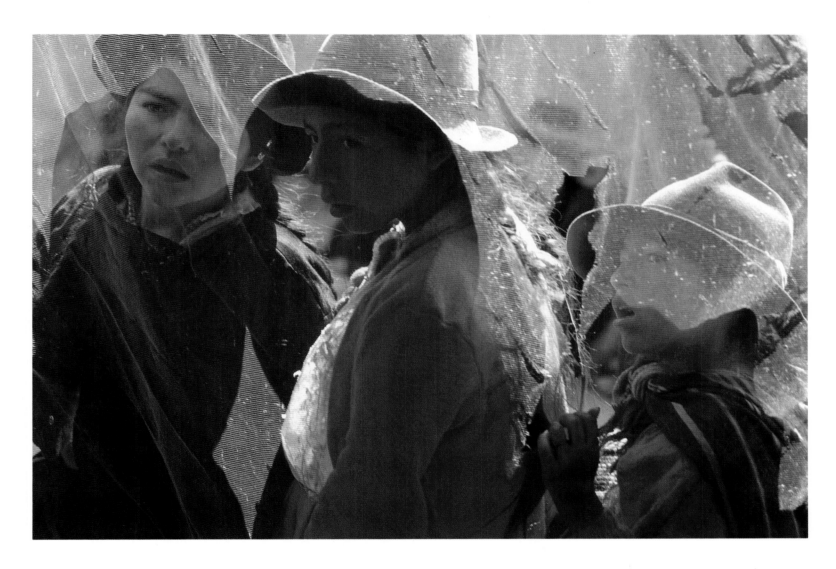

PERU 1981

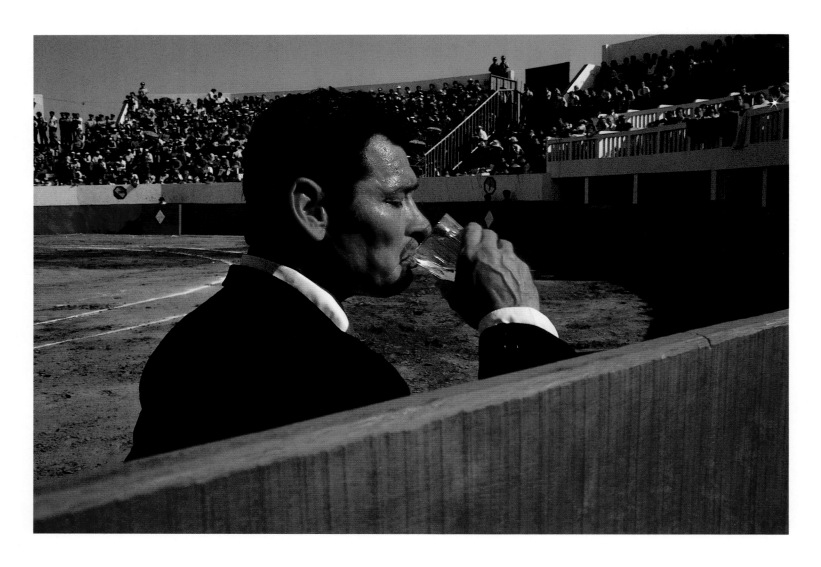

PERU 1981

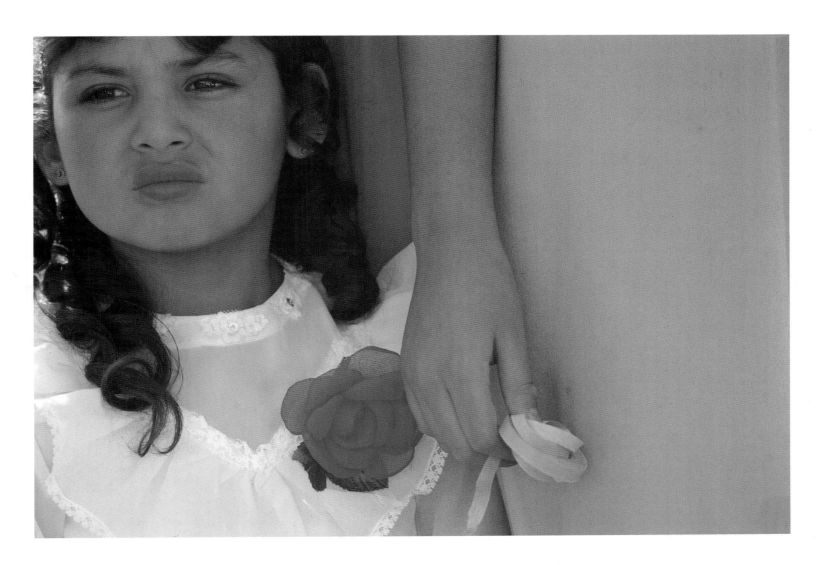

PERU 1981

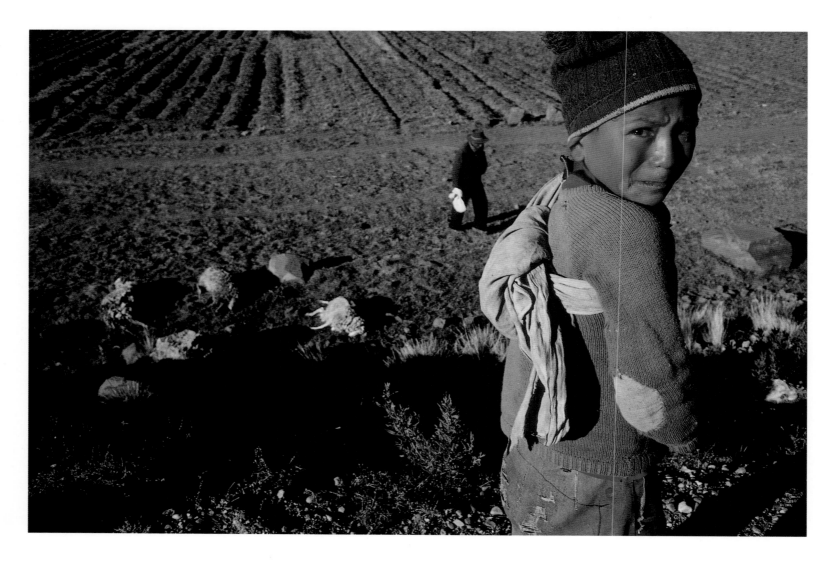

PERU 1981

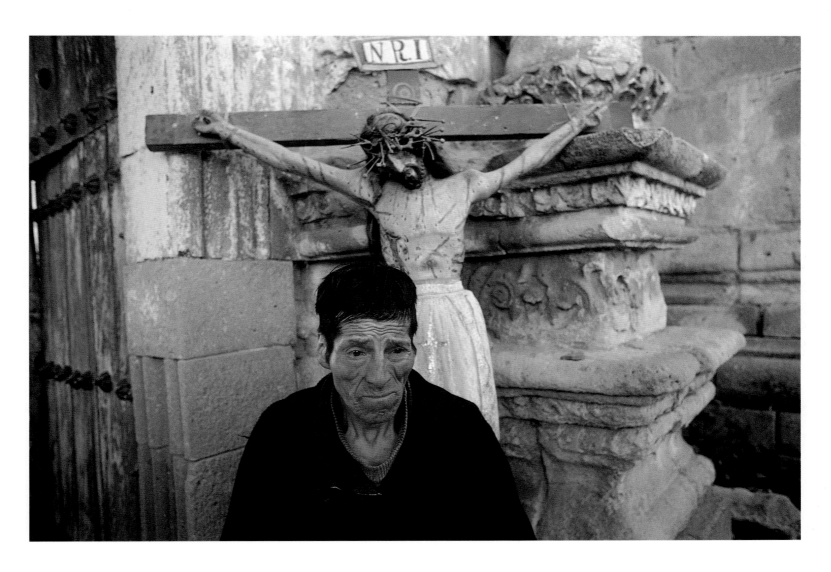

PERU 1981

# TEA AND SUGAR TRAIN

I went to Australia in the fall of 1985 to troubleshoot for a *National Geographic* article about this train. They weren't satisfied with the pictures they had. It was right at the point where Rich Clarkson, the new director of photography, was bringing me back to work for the *Geographic*. I'd already been assigned to do some work for the book division, but I hadn't gotten back into the magazine yet. So I said to Rich, if you need somebody to do this job, I'll take a crack at it. Then I saw the pictures, and I thought, this is not a piece of cake—this is desolate country with a minimum of picture opportunities.

The Tea and Sugar is a weekly supply train that travels across southern and western Australia, stopping at all the desolate little sidings populated by railway workers. In a situation like this, you're being examined by your subjects as closely as you're examining them. You represent something different in their lives. But they were generally quite accepting. I don't make it a point to say 'I'm from the *National Geographic*,' at least until someone asks. It changes the situation, and you don't want that.

Many of the railway workers are members of what they call "flying gangs" of *fettlers*, men who take out the old wooden railroad ties and replace them with concrete ones. For all the new machinery they use, it's still very hard work, especially in the summer. Their camp has a kind of pool room and bar setup where the men relax after work (p. 125).

Henry Cox—"Coxie"—was a train inspector at Cook, which is the main depot by the border between Western and South Australia (p. 128). We were just talking, drinking a beer. He's leaning on a water tank, a reservoir for the tiny local fire station. The tank is covered over to keep children from falling in, I guess.

There are some assignments, such as this one, where getting in and out is a bit more of a job than usual. Getting off the train to do some pictures and waiting to be picked up again sometimes meant several days in one place. While you're there, you have even more of a chance to investigate any picture possibility that will reveal the character of the place.

Cook has a swimming pool surrounded by a fine mesh screen to keep out the blowing dust. I was taking pictures around the pool, but I was thinking the time of day was wrong, the light was harsh and unattractive. I was leaving when I saw a young boy on the other side of the screen, which softened the light and created a strange image (p. 129).

The young fettler and his wife and baby live in one of the small settlements along the line, with five or six other families (p. 124).

One night I went out with a kangaroo hunter. He was very apprehensive of my being with him, because shooting kangaroos is a controversial issue. Roo shooters, as they're called, are hired by the big ranch owners. If a rancher can prove that kangaroos are cutting into his cattle's grazing territory, he can get a permit to hire a roo shooter. Some of these guys live in the Outback for months at a time. They go out at night with spotlights and high-powered, high-velocity rifles and kill the kangaroos for their meat and hide. The tail is sometimes made into a sandwich spread; I think the rest of the meat is used in dog food. This man only shot one kangaroo while I was with him. The picture is a mixture of strobe and existing light, heavy on the strobe (p. 127).

Every year a train inspector named Alf Harris comes out on the train dressed as Santa Claus to give the children presents. The aborigines don't like you to take their pictures, but this incongruity of this situation was irresistible. I took two pictures; this is the better one, because of that upraised little finger (p. 131). It makes all the difference. It appears to be a gesture of curiosity or wonder. So often when you make a picture, it's a matter of inches, or a matter of a small gesture. I was fortunate to have those scattered clouds in the sky to give some relief to that blue, and as a repetition of Santa's beard. Of course, I don't see all these subtleties when I take the picture, but I think they often register on a subconscious level.

Unlike the Santa photograph, I had time to think about the picture of the abandoned cafe (p. 132). It's in Rawlinna. I exposed a good number of frames of it. I probably got closer, switched lenses, and played out the technical options. It wouldn't be as good a picture without the "Keep Out" sign on the cafe door. It gives the picture more meaning. This isn't a downtown place. It's Emptyville.

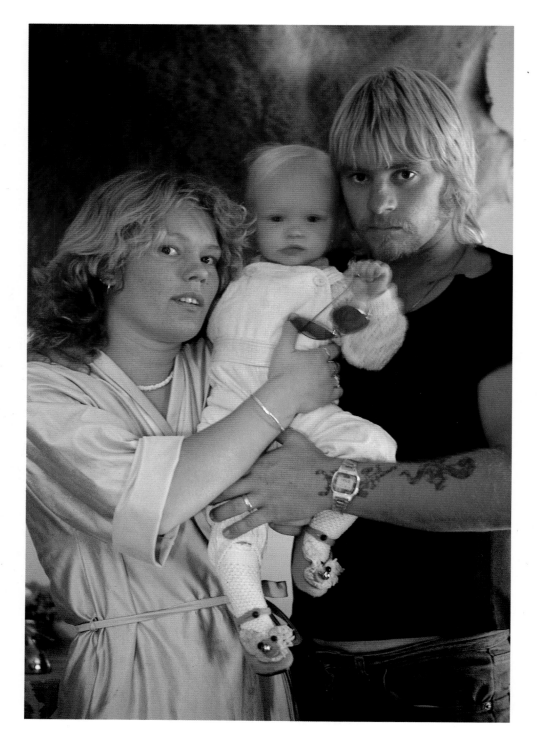

RAILROAD FETTLER DAVID BABBAGE,
WITH WIFE ALICIA, AND DAUGHTER DANI, SOUTH AUSTRALIA 1985

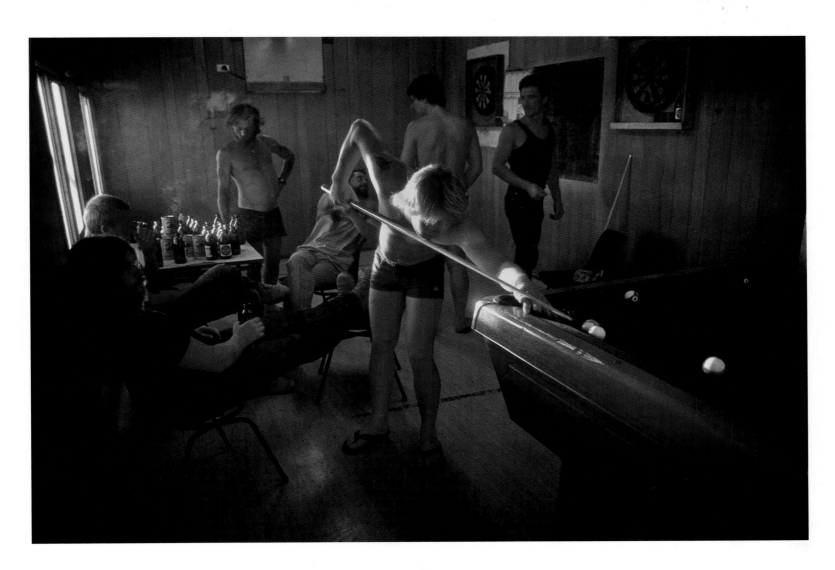

RAILROAD FETTLERS, WESTERN AUSTRALIA 1985

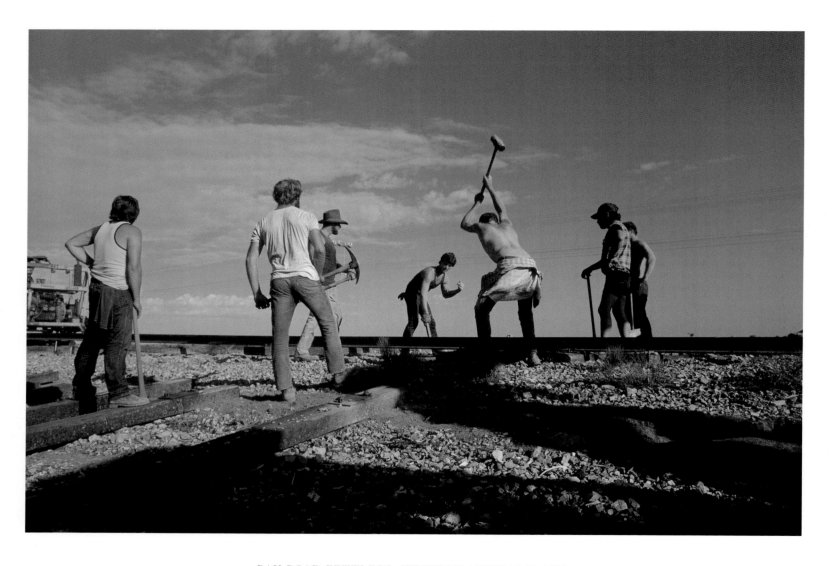

RAILROAD FETTLERS, WESTERN AUSTRALIA 1985

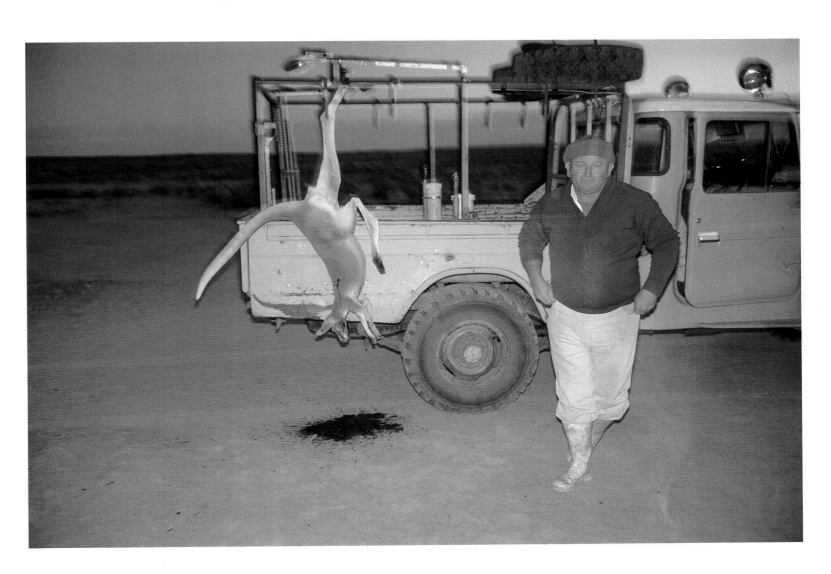

KANGAROO SHOOTER, SOUTH AUSTRALIA 1985

HENRY COX, SOUTH AUSTRALIA 1985

SOUTH AUSTRALIA 1985

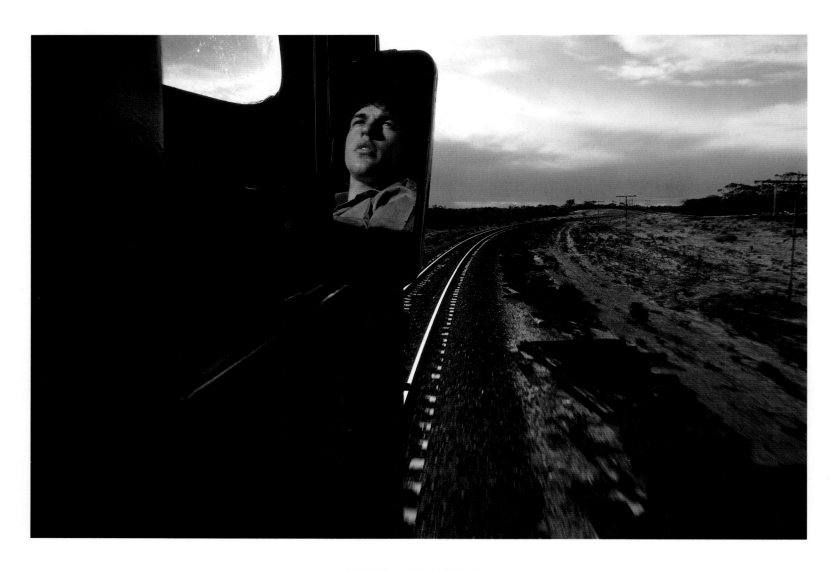

SOUTH AUSTRALIA 1985

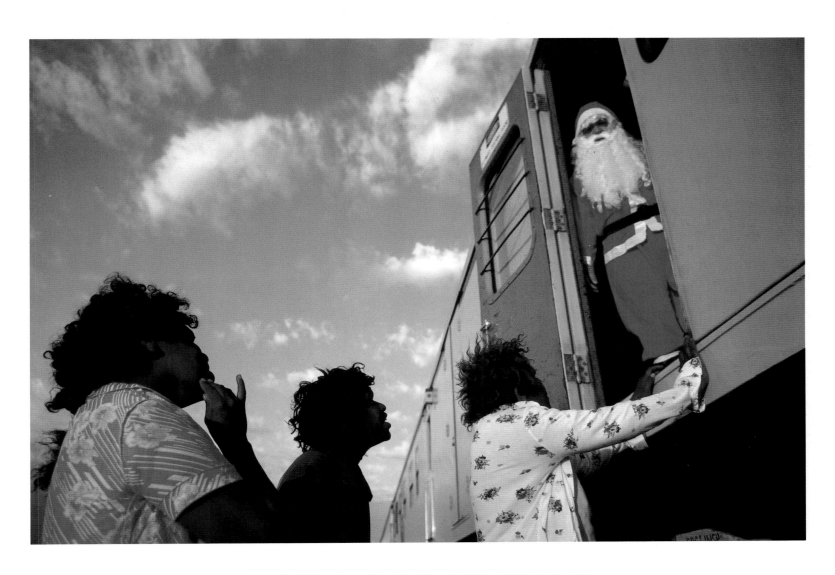

ALF HARRIS AS SANTA CLAUS, SOUTH AUSTRALIA 1985

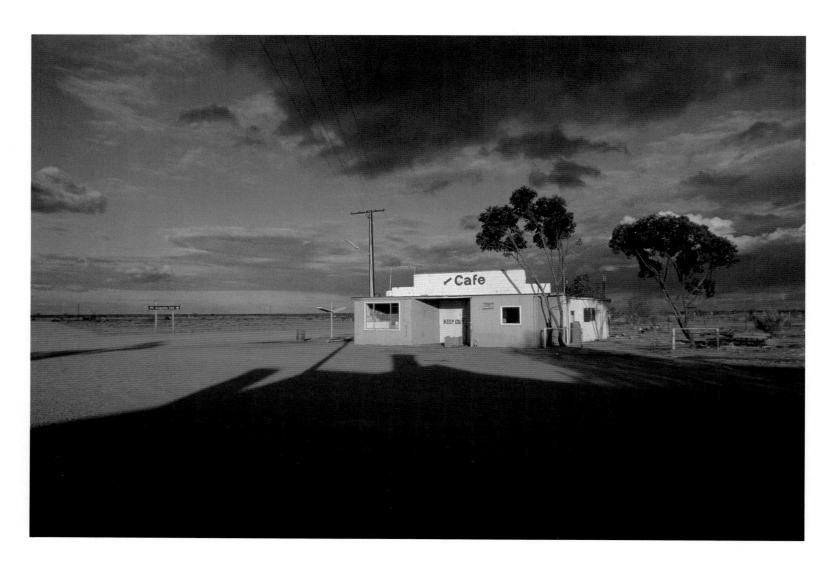

RAWLINNA, SOUTH AUSTRALIA 1985

AUTHORS' ACKNOWLEDGMENTS

Undertaking a book of any length entails obligations, for which a listing here is small repayment. The authors' greatest debt is to Bill Allard, for the intelligence and professionalism with which he supported this collaboration. His colleagues, some of whom are not quoted directly or clearly attributed, deserve mention for their valuable insights: Sam Abell, Harvey Arden, Kay Bazo, Jim Blair, Ira Block, Rich Clarkson, Wilbur Garrett, Robert Gilka, David Alan Harvey, Declan Haun, Kent Kobersteen, John Loengard, Jon Schneeberger, R. Smith Schuneman, Tom Smith, Jim Stanfield, Bill Thomas, and Sam Yanes. Special thanks must go to Ann Louise Allard deGray for her generosity in discussing family history, and to Lilian Davidson for many helpful suggestions. We are also grateful to Ani Allard for her unfailing kindness and hospitality throughout. And many thanks to Guy St. Clair, who did far more to help than even he suspects.

The editorial and production team behind the book also merits special mention — the editors, Henry Horenstein of Pond Press and Janet Bush of Bulfinch Press and the designer, Lisa DeFrancis. Thanks also to Sean Callahan, longtime editor of *American Photographer*, for his help and support.